# CONTEMPORARY
## FOLK ART

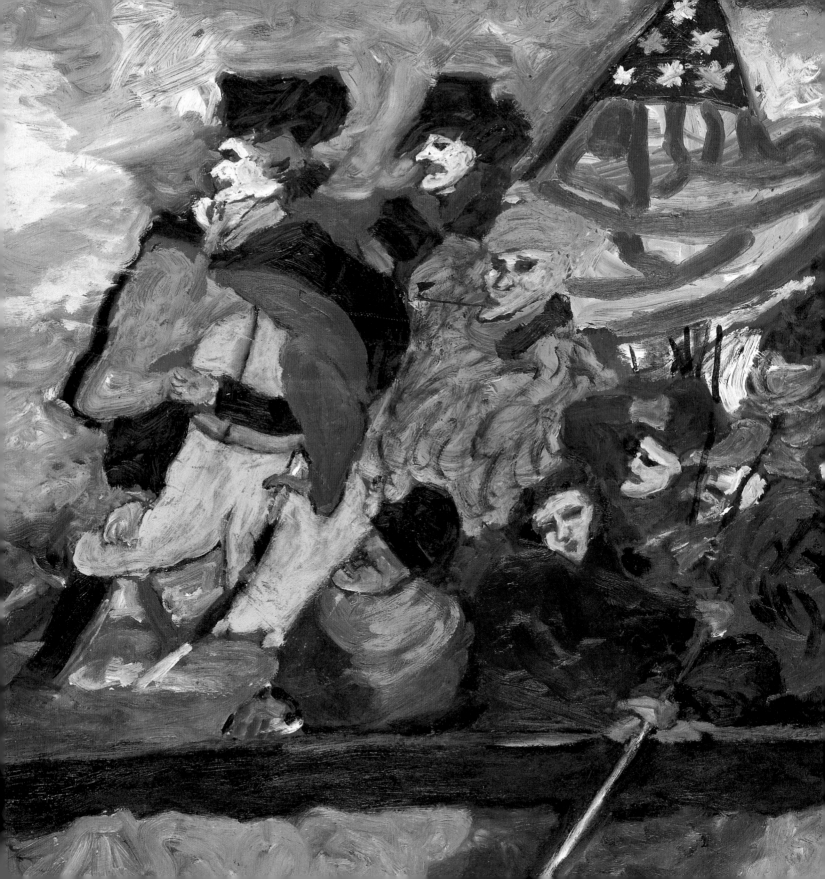

# CONTEMPORARY FOLK ART

## Treasures from the
## Smithsonian American Art Museum

*Tom Patterson*

Watson-Guptill Publications/New York

Smithsonian American Art Museum

Contemporary Folk Art: Treasures from the
Smithsonian American Art Museum

By Tom Patterson

Chief, Publications: Theresa Slowik
Designers: Steve Bell, Robert Killian
Editor: Timothy Wardell
Editorial Assistant: Sara Mauger

Library of Congress Cataloging-in-Publication Data

Patterson, Tom.
  Contemporary folk art : treasures from the
Smithsonian American Art Museum / Tom Patterson.
    p. cm.
Includes index.
  ISBN 0-8230-0938-6
  1. Folk art—United States—History—20th
century—Catalogs. 2. Primitivism in art—United
States—Catalogs. 3. Folk art—Washington
(D.C.)—Catalogs. 4. Smithsonian American Art
Museum (U.S.)—Catalogs.
I. Smithsonian American Art Museum (U.S.) II.
Title.
  NK808.P38 2001
  745'.0973—dc21
                                00-012861

Printed and bound in Italy

First printing, 2001
1 2 3 4 5 6 7 8 9 / 08 07 06 05 04 03 02 01

Cover: Unidentified Artist, *Bottlecap Giraffe* (detail),
completed after 1966, bottlecaps on painted wood
with marbles and animal hair and fur. Smithsonian
American Art Museum, Gift of Herbert Waide
Hemphill Jr. and museum purchase made possible
by Ralph Cross Johnson (see page 98).

Frontispiece: Justin McCarthy, *Washington Crossing the
Delaware, Variation on a Theme #3* (detail), about 1963,
oil. Smithsonian American Art Museum, Gift of
Herbert Waide Hemphill Jr. (see page 66).

*Contemporary Folk Art* is one of eight exhibitions in *Treasures to Go,* from the Smithsonian American Art Museum, touring the nation through 2002. The Principal Financial Group® is a proud partner in presenting these treasures to the American people.

## Foreword

Museums satisfy a yearning felt by many people to enjoy the pleasure provided by great art. For Americans, the paintings and sculptures of our nation's own artists hold additional appeal, for they tell us about our country and ourselves. Art can be a window to nature, history, philosophy, and imagination.

The collections of the Smithsonian American Art Museum, more than one hundred seventy years in the making, grew along with the nation itself. The story of our country is encoded in the marvelous paintings, sculptures, and other artworks we hold in trust for the American people.

Each year more than half a million people come to our home in the historic Old Patent Office Building in Washington, D.C., to see great masterpieces. I learned with mixed feelings that this neoclassical landmark was slated for renovations. Cheered at the thought of restoring our magnificent showcase, I felt quite a different emotion on realizing that this would require the museum to close for three years.

Our talented curators quickly saw a silver lining in the chance to share our greatest, rarely loaned treasures with museums nationwide. I wish to thank our dedicated staff who have worked so hard to make this dream possible. It is no small feat to schedule eight simultaneous exhibitions and manage safe travel for more than five hundred precious artworks for more than three years, as in this *Treasures to Go* tour. We are indebted to the dozens of museums around the nation, too many to name in this space, that are hosting the traveling exhibitions.

The Principal Financial Group® is immeasurably enhancing our endeavor through its support of a host of initiatives to increase national awareness of the *Treasures to Go* tour so more Americans than ever can enjoy their heritage.

*Contemporary Folk Art* captures a unique part of the American experience. Tom Patterson guides us through a world of portraits, religious inspiration, and political satire. These artists express their vision with paint, clay, glitter, wood, tin, bottlecaps, and wool as they sculpt, weave, carve, and fashion a world at once fantastic and familiar. When we have their own accounts of their work, they speak of the joy and freedom they find in creation, and the compulsion to express themselves. Often without the benefit of traditional training, they approach their work with an abandon that can be intoxicating and a devotion that inspires awe.

Some of the work in this book is clearly made for public purposes, other pieces are intensely private. The artists are sometimes reclusive, and sometimes verge on the confrontational. Folk artists use every material that comes to hand and every process the mind can conceive. Howard Finster, one of the artists represented here, once called folk artists "the lone and forgotten." The passion he and the others have brought to their art ensures that they will never be forgotten.

The Smithsonian American Art Museum is planning for a brilliant future in the new century. Our galleries will be expanded so that more art than ever will be on view. We are planning new exhibitions, sponsoring research, and creating educational activities to celebrate American art and understand our country's story better.

Elizabeth Broun
*Margaret and Terry Stent Director*
*Smithsonian American Art Museum*

**LEROY ALMON SR.**

1938–1997

## *Hell*

1990, enamel on
redwood with nails
91.4 x 57.1 x 1.9 cm
Smithsonian
American Art
Museum, Gift of an
anonymous donor

In case the flames and two devils don't adequately identify this scene, Almon has added a white banner emblazoned "HELL" at the top. The illuminated central figure of Christ—whom Almon depicts as dark-skinned—holds the key to redemption. His triumph is symbolized by the defeated devils that surround him, their weapons surrendered and their wrists bound. A crowd of frowning faces represents the souls condemned for eternity.

After working as a salesman for more than twenty years, Almon apprenticed himself to a religious carver, Elijah Pierce. Almon worked with Pierce in Columbus, Ohio, for about three years, and then returned to his childhood home of Tallapoosa, Georgia. He was a dispatcher for the local police department, but he described himself as a folk artist on his business cards, and established a reputation to match that title.

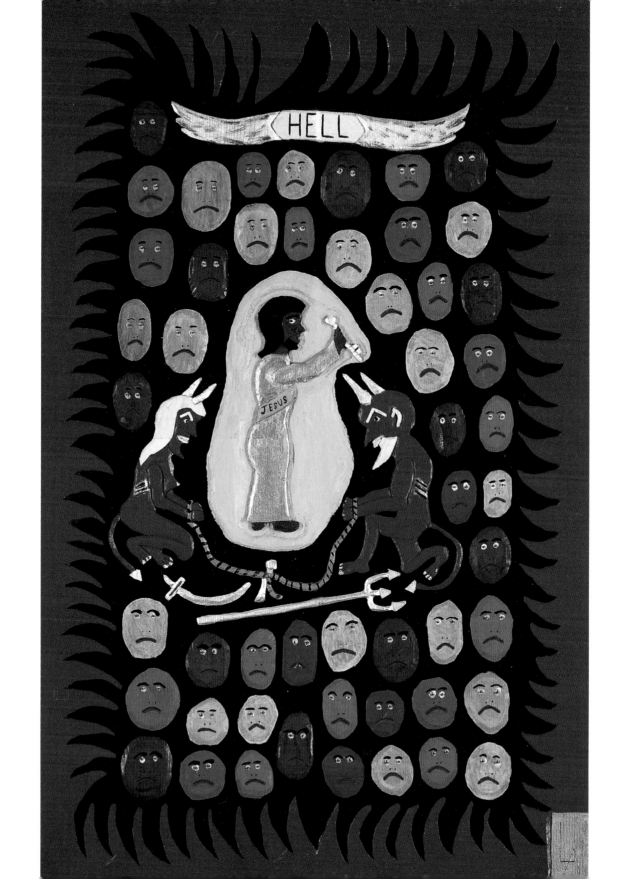

**JOHNSON ANTONIO**

born 1931

## *Seven Navajo Figures*

1985–92, acrylic
and watercolor on
cottonwood with
yarn and cloth
various sizes
Smithsonian
American Art
Museum, Gift of
Chuck and Jan
Rosenak and
museum purchase
through the Luisita L.
and Franz H.
Denghausen
Endowment

This group of columnar figures, vaguely reminiscent of the kachina dolls that New Mexico's Hopi people have used for centuries in their religious ceremonies, actually represent Antonio's Navajo neighbors. Rather than supernatural characters, Antonio's sculptures depict real individuals, with characteristic hairstyles and clothing. They hold traditional objects, such as the ear of "Indian corn" and the Navajo blanket draped over the arm of one woman. A small dog sits at the feet of one figure—a motif that recurs in Antonio's work, in which humans and animals are often intimately connected.

A former railroad worker, this Navajo artist also spent years herding sheep and goats in northern New Mexico's thinly populated Bisti region. He was in his early fifties when he began carving small sculptures from the local cottonwood. By carving secular human figures, he consciously violated a Navajo taboo, but his need to portray the Native American society in which he spent his life proved stronger than tradition.

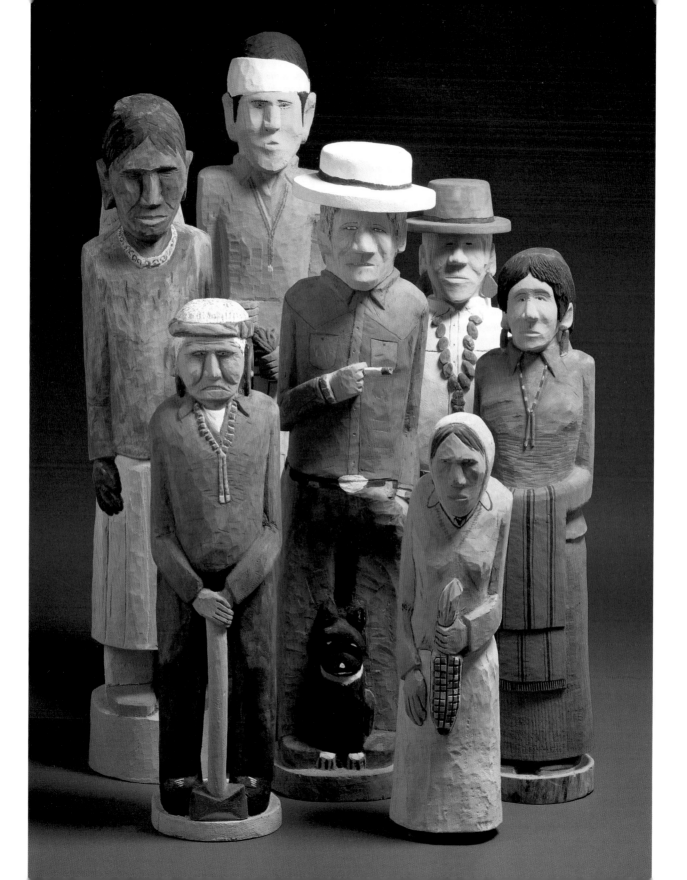

## FELIPE ARCHULETA

1910–1991

# *Tiger*

1977, painted
cottonwood
with marbles
90.2 x 159.4 x 49.5 cm
Smithsonian
American Art
Museum, Gift of
David L. Davies

This fierce jungle cat, with vivid stripes and prominent teeth and claws, typifies the mature work of one of the Southwest's most widely acclaimed folk sculptors. Archuleta concentrated almost exclusively on animal carving, and he loved the more formidable species. Before he began carving in the early 1960s, Archuleta had spent his life working as a migrant farm worker, shepherd, short-order cook, carpenter, and drummer. Living in a region where the Hispanic *santero* woodcarving tradition has deep roots, Archuleta chose a more personal path in his work. Though he said that he began carving in response to a divine command, his subjects are nearly always secular. The sophistication and realistic presence of his carvings defy the stereotype of the "pure" folk artist, untainted by outside influences. His work began to attract attention around 1970, and by the time he made this piece, he had become quite the "tiger" himself. A hero and role model in his community, he inspired a flourishing local woodcarving tradition whose most prominent exponent is his son, Leroy Ramon Archuleta.

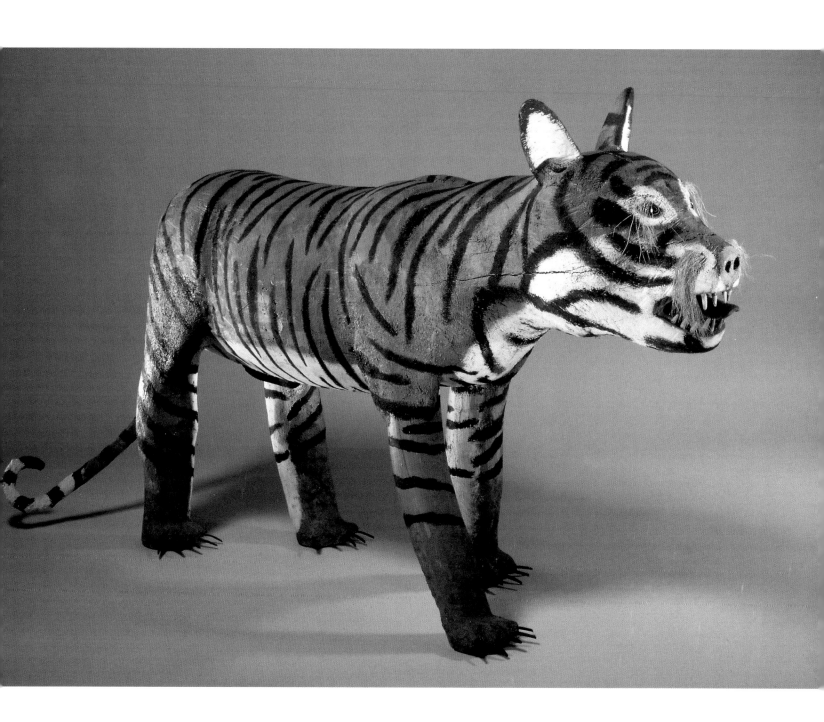

PETER "CHARLIE"
ATTIE BESHARO

1899–1962

# Lady Liberty of 1953 to 1962?

about 1962
acrylic and metallic
paint and pencil
57.5 x 72.5 cm
Smithsonian
American Art
Museum, Gift of
Herbert Waide
Hemphill Jr. and
museum purchase
made possible by
Ralph Cross Johnson

The Statue of Liberty meets Flash Gordon's spaceship! A fancifully dressed woman shackled into a harness and guided by a headlamp is propelled by a flame-shooting flying machine across a cloudless azure sky. The eyes that stare from her torso suggest heightened perceptual powers, while the texts floating around her and emblazoned on the rocket's hull hint at a possible political message.

Besharo's painting was a completely private activity during his lifetime. His neighbors in Leechburg, Pennsylvania, knew this Syrian immigrant as a housepainter and handyman who generally kept to himself. At his death in 1962, sixty-nine paintings were found in a rented garage. The prominent question mark on *Lady Liberty* seems to anticipate that moment of discovery and our desire to ask the artist, "What is it, and what does it mean?"

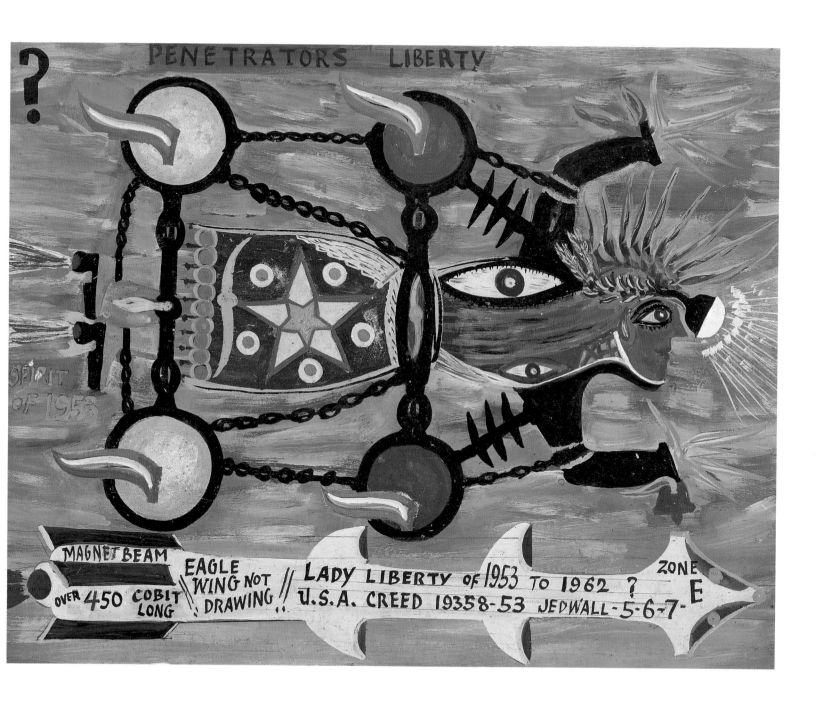

**CALVIN BLACK**

1903–1972

**RUBY BLACK**

about 1915–1980

# *Sylvia*

about 1953–72
painted redwood
with cloth
111.2 x 33.1 x 20.4 cm
Smithsonian
American Art
Museum, Gift of
Herbert Waide
Hemphill Jr. and
museum purchase
made possible by
Ralph Cross Johnson

*Sylvia* is one of more than eighty hand-carved, painted, life-sized dolls made by the Blacks to populate Possum Trot, the roadside environment they built in the Mojave Desert near Yermo, California, after moving there in 1953. A childless couple, both native to the American South, the Blacks opened a rock shop and refreshment stand along Highway 15. To attract passing tourists the Blacks surrounded their establishment with a massive display of totem poles, painted signs, large figural whirligigs, tableaus, carousels, and, most notably, their homemade dolls. Sylvia sat on one of the outdoor carousels, which accounts for her faded, windblown appearance.

In an outbuilding they called the Birdcage Theatre, the Blacks regularly presented their "Fantasy Doll Show," a theatrical production in which some of the dolls were given recorded falsetto voices and manipulated to act out tales of the Wild West. Calvin Black, a ventriloquist and former carnival worker, carved the dolls from damaged redwood power-line poles and sugar pine. He painted them, wired those used in the show for sound, provided their voices, animated them, and recorded his own guitar and vocal soundtracks for these dramatized vignettes. Ruby Black made the dolls' clothing.

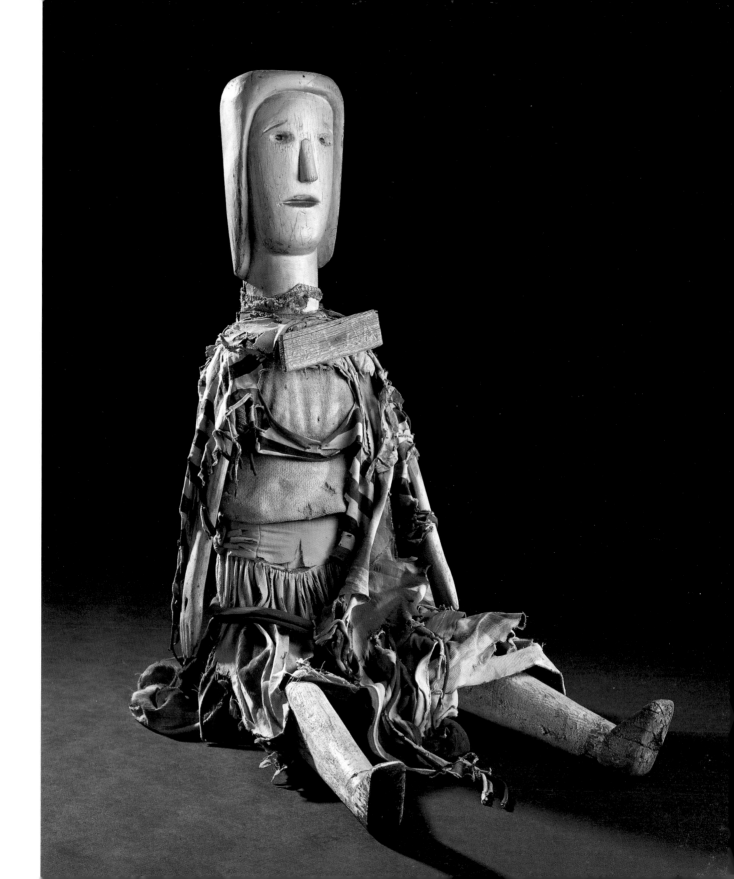

**WILLIAM ALVIN BLAYNEY**

1917–1986

# Mural No. GU-43752 (All Rights Reserved)

1969, 1971
oil, ink, and pencil
on masonite
94.6 x 62.9 cm
Smithsonian
American Art
Museum, Gift of
Chuck and Jan
Rosenak and
museum purchase
through the Luisita L.
and Franz H.
Denghausen
Endowment

This visionary work consists of five vignettes, each depicting events, places, and supernatural beings described in the apocalyptic book of the Bible known as The Revelation of Saint John the Divine. Saint John's visions took place on the Aegean island of Patmos, and Blayney has used them as the principal source for this text-filled painting, which combines a crowded composition with a bright palette and myriad biblical citations, codes, and cryptic text.

During the 1950s, Blayney lived in Pittsburgh and ran an automobile repair business. After a profound religious conversion, he left his wife and business, moved to Oklahoma, and began to paint. By the time he produced this mural he was supporting himself by driving a bulldozer even as he gained a local reputation as a Pentecostal preacher. He considered his art and preaching to be the fulfillment of a biblical prophecy.

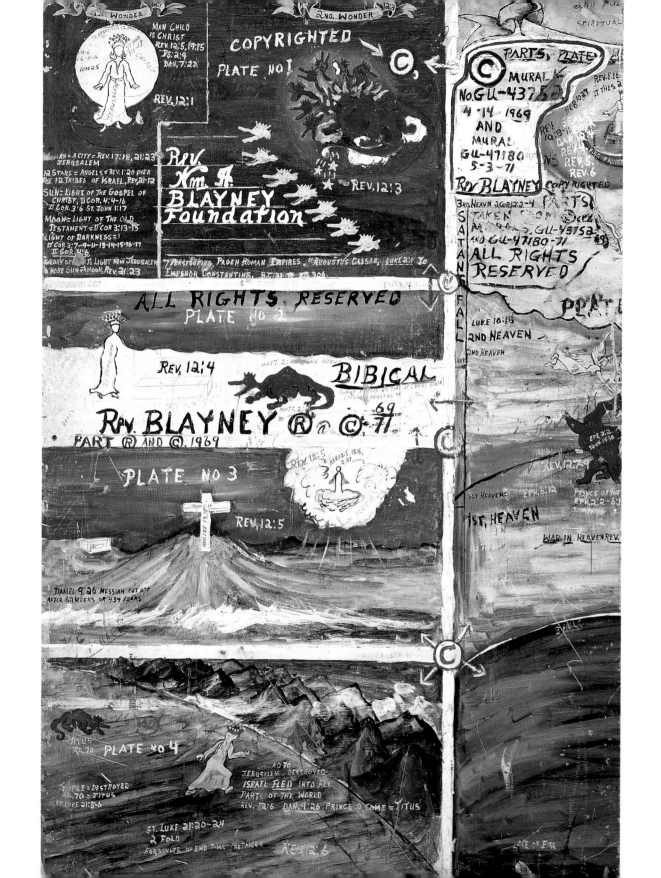

## MILES BURKHOLDER CARPENTER

1889–1985

# Indian Woman

about 1970
painted wood, cloth,
and leather
125.7 x 50.7 x 76.2 cm
Smithsonian
American Art
Museum, Gift of
Herbert Waide
Hemphill Jr. and
museum purchase
made possible by
Ralph Cross Johnson

This life-sized carving was among several Carpenter displayed in the pickup truck that he drove around his adopted hometown of Waverly, Virginia, during the last twenty years of his life. She and her male counterpart, along with their child, were actually advertisements for Carpenter's roadside vegetable stand. This woman has articulated arms and red-painted fingernails, and she is busily engaged in hooking a rug. Her coarse hair is made from unraveled rope, and she is dressed in clothing and shoes left behind by Carpenter's deceased wife.

Carpenter was active as a wood-carver since the 1940s, and he devoted himself wholeheartedly to his art after his wife's death in 1966. To the amusement of his neighbors, he occasionally placed this or another figure in the passenger seat of his pickup truck as he drove through town.

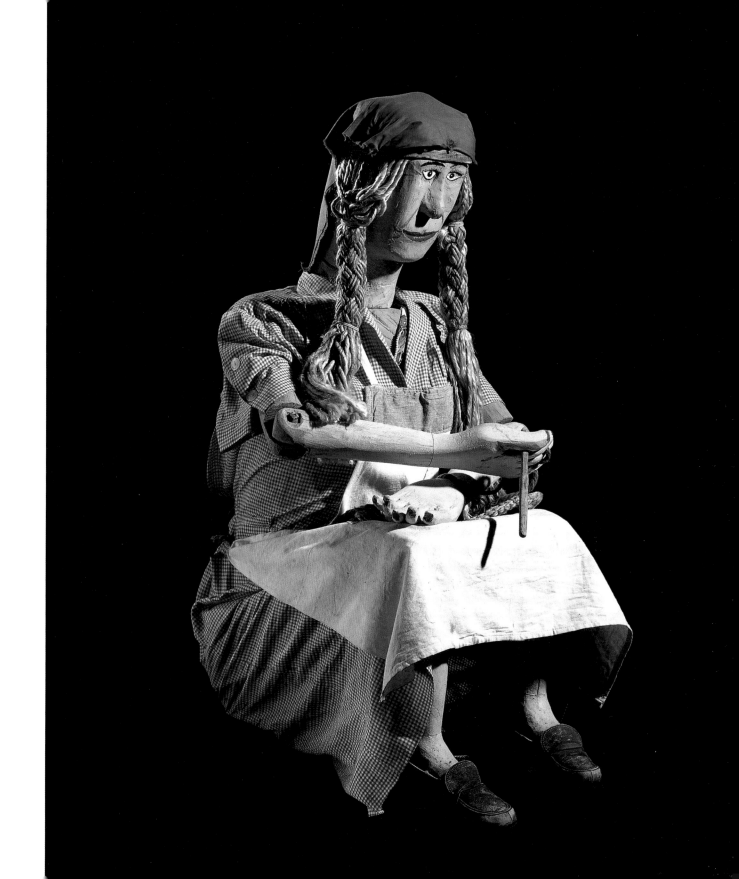

## MILES BURKHOLDER CARPENTER

1889–1985

## *Root Monster*

1968, painted
tree roots, rubber,
and string
57.5 x 72.7 x 71.6 cm
Smithsonian
American Art
Museum, Gift of
Herbert Waide
Hemphill Jr. and
museum purchase
made possible by
Ralph Cross Johnson

This lively creature with vivid stripes and bared fangs seems poised for attack or self defense. It reminds us of creatures described in Greek mythology—especially Cerberus, the multiheaded canine guardian of Hades. Carpenter, who operated a lumber business for more than forty years, enjoyed adapting the natural forms wood takes to suit his own creative purposes. He believed that figural forms are inherently present in such irregularly shaped pieces of wood, waiting to emerge through an artist's creative manipulation.

Carpenter's views have been shared by a number of other American vernacular "root sculptors." Some have conceived their sculptures as protectors and guardians. Other works are largely whimsical in intent; they are made for the pleasure of entertaining an audience and the desire to extract an animate form from the wood.

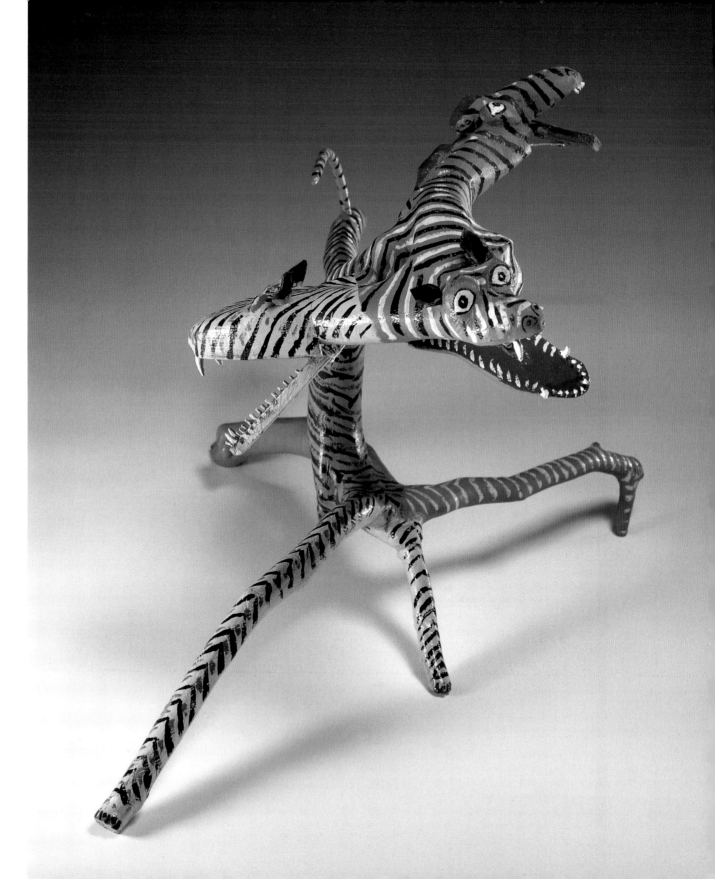

**EARL CUNNINGHAM**

1893–1977

## *Seminole Indian Summer Camp*

about 1963
oil on masonite
42.9 x 103.5 cm
Smithsonian
American Art
Museum, Gift of
Michael and
Marilyn Mennello

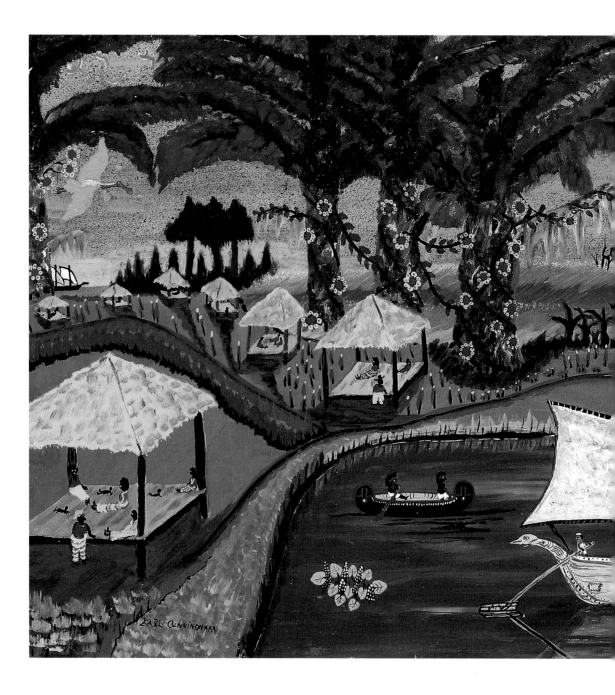

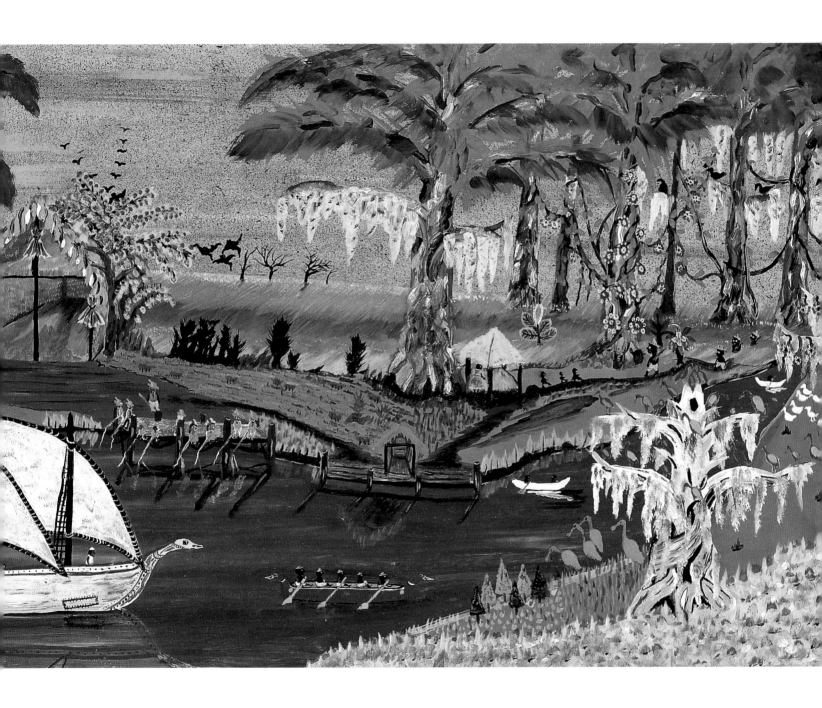

**ULYSSES DAVIS**

1913–1990

## *Beast Going through the Grass*

about 1984–85
painted wood with
rhinestones
89.2 x 24.4 x 17.1 cm
Smithsonian
American Art
Museum, Museum
purchase made
possible by
Ralph Cross Johnson

This fearsome-looking reptile with a fish in its mouth is typical of Davis's work in its level of fine detail—the painstakingly rendered fish scales and the tiny, sharp, spikes that line the dragonlike beast's head and back. This is one of the more imaginative pieces created by Davis, a former railroad worker who turned to cutting hair after his retirement in the early 1960s. For the remainder of that decade and through the 1980s, his Ulysses Barber Shop, behind his house in Savannah, doubled as a gallery for displaying his impressive body of wood sculptures.

Davis developed his wood-carving skills on his own over a period of more than fifty years, beginning during his childhood in Fitzgerald, Georgia. He carved portraits of historical and biblical figures, realistic animals, and fanciful portraits of African tribal leaders as well as dragonlike beasts. Although he stained many of his carvings, his use of paint, as in this sculpture, was relatively rare. Despite persistent pleas from art collectors and dealers, Davis refused to sell his works throughout his lifetime, making very few exceptions. "They're part of me," he insisted. He called them his "treasure," and said, "If I sold these, I'd really be poor."

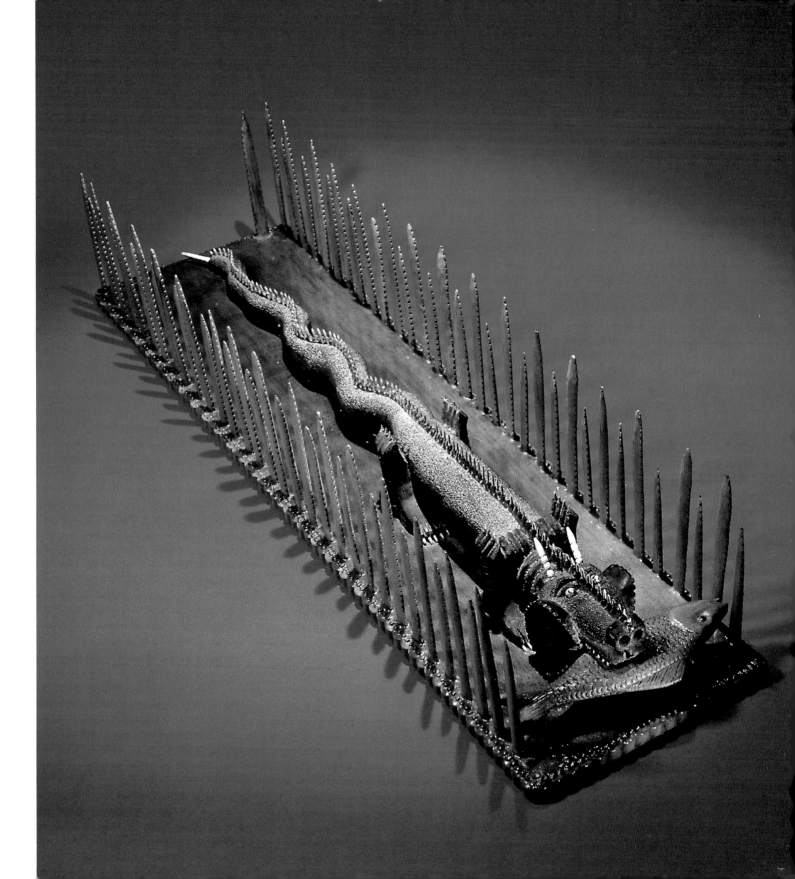

## MAMIE DESCHILLIE

born 1920

# *Buffalo*

1987, paint, cloth,
and costume jewelry
on cardboard
97.2 x 120 x 13 cm
Smithsonian
American Art
Museum, Gift of
Chuck and Jan
Rosenak and
museum purchase
through the Luisita L.
and Franz H.
Denghausen
Endowment

With his wide-eyed expression and toothy grin, this cutout *Buffalo* turns his head, almost as if to ask a question. He leans slightly toward us, balanced on narrowly spaced feet, while his beaded earrings dangle jauntily beneath his horns. The top-heavy composition adds a sense of precarious balance to the piece. The American buffalo, or bison, stands alongside the bald eagle as a powerful cultural symbol, but here has an almost cartoonlike quality.

Mamie Deschillie began making animal and human cutout figures in the late 1980s, five or six years after she launched her late-life art career. She began by making mud "toys" encrusted with found objects. Her primary subjects have been the Navajo people and their animals.

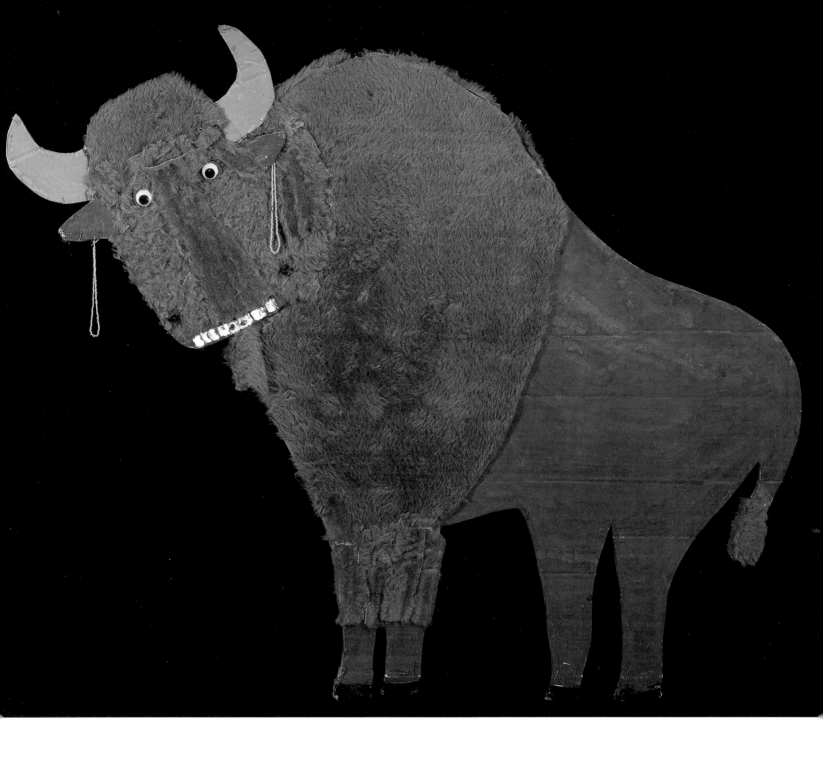

JOHN WILLIAM
"UNCLE JACK" DEY

1912–1978

## *Acupuncture Pitchfork Style*

about 1974
model airplane
enamel on wood
58.5 x 91.5 cm
Smithsonian
American Art
Museum, Gift of
Chuck and Jan
Rosenak and
museum purchase
through the Luisita L.
and Franz H.
Denghausen
Endowment

In a tranquil rural landscape stands a red-roofed log cabin with a smoking chimney and some fruit-laden trees against a backdrop of evergreens. A male figure flies a kite as he balances backward on the hindquarters of a galloping yellow horse. But isn't there something ominous about the large flock of black birds diving through the cloud-dappled sky? A smiling woman in a blue mini-dress has skewered a man on a pitchfork. As he dangles, bleeding, over a vat of "Mince Pie Mix with Rum," he holds a ladle that suggests that he might have been stealing some of this special mix for the woman's "Exotic Pies." The naive style, bright colors, and comic touches, such as the birds perched on kite strings, give the work a slapstick edge.

The tree stumps and felled trees in the foreground recall Dey's stint as a lumberjack in Maine during the early 1930s. By the mid-1930s he had returned to his native Virginia and settled in Richmond, where he worked as a barber for several years before joining the police force. He turned to painting soon after his retirement from the force in 1955. The rural setting, the template-outlined horse and birds, and the comical details in this piece are all typical of his work.

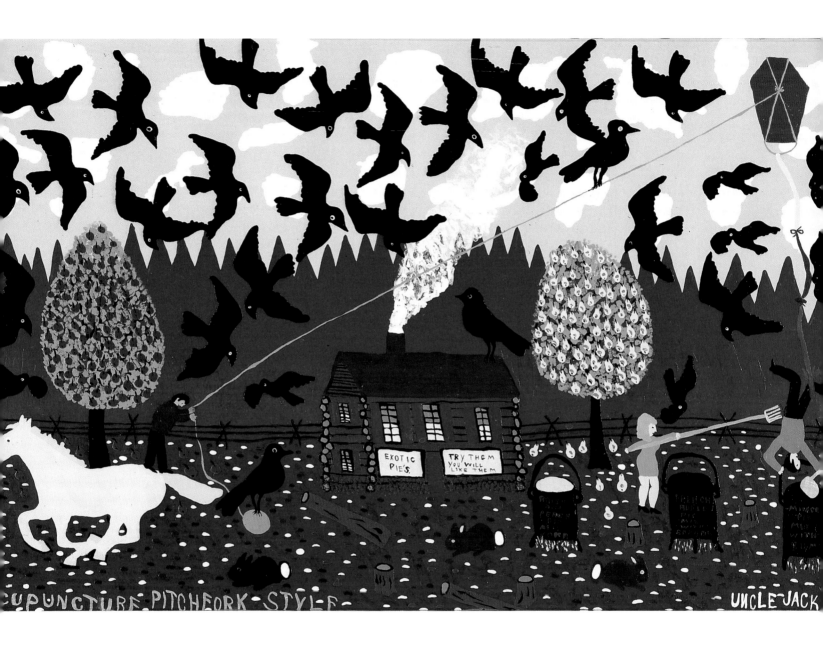

**THORNTON DIAL SR.**

born 1928

# *Top of the Line (Steel)*

1992, enamel,
roping, and found
metal objects on
canvas and plywood
165.2 x 205.7 x 20.1 cm
Smithsonian
American Art
Museum, Gift from
the collection of
Ron and June Shelp

The title of this work, *Top of the Line,* refers to the quality of products made by American industrial workers, and Dial has incorporated pieces of such appliances—a refrigerator, a stove, and a washing machine—into the painting. This assemblage and the paint are applied to industrially braided fabric; Dial's choice of materials is a part of his political statement. Birmingham, Alabama, where Dial lived and worked, has been a steel town for most of the twentieth century. Dial worked in a plant that manufactured rail cars from that steel, and during the 1980s he began making art that had a strong element of social criticism.

*Top of the Line* is one of several paintings Dial made in response to the uprising in South Central Los Angeles during the summer of 1992. As he watched the news coverage of the story, Dial was struck by how quickly the demonstration of social outrage—aimed at police officers who beat an unarmed black motorist and a jury that acquitted them of any offense—degenerated into widespread burning and looting of area businesses. The colors he uses—red, blue, white, and black—are emblematic of racial conflict and urban gang warfare in the United States, but his statement is also about economics. Many of the workers who produce "top-of-the-line" industrial goods cannot afford to buy them; according to the artist, the parenthetical subtitle is a pun on the words "steel" and "steal."

**IRVING DOMINICK**

1916–1997

# *Marla*

1982
galvanized iron
149.9 x 89.5 x 37.3 cm
Smithsonian
American Art
Museum, Gift of
Herbert Waide
Hemphill Jr.

The tilt of *Marla*'s head makes her look as if she is smiling up at us. Her charming gaze is enhanced by her mane of tousled hair and her meticulously cut and crimped lashes. She is made of galvanized ductwork and sheet metal typically used for air-conditioning systems and gutters.

Dominick was a sheet metal worker for more than fifty years. On the roof of his father's sheet metal shop in Brooklyn stood a large tin figure constructed by the shop foreman. Dominick took this shop sign with him when the family business moved to Spring Valley, New York. He made his first figure shortly before his retirement in 1982, after he sold the original "Tiny Tin" to a passerby who offered him what he considered a fair price. Marla, named for Dominick's ten-year-old granddaughter, was made when a collector asked him to make a female figure.

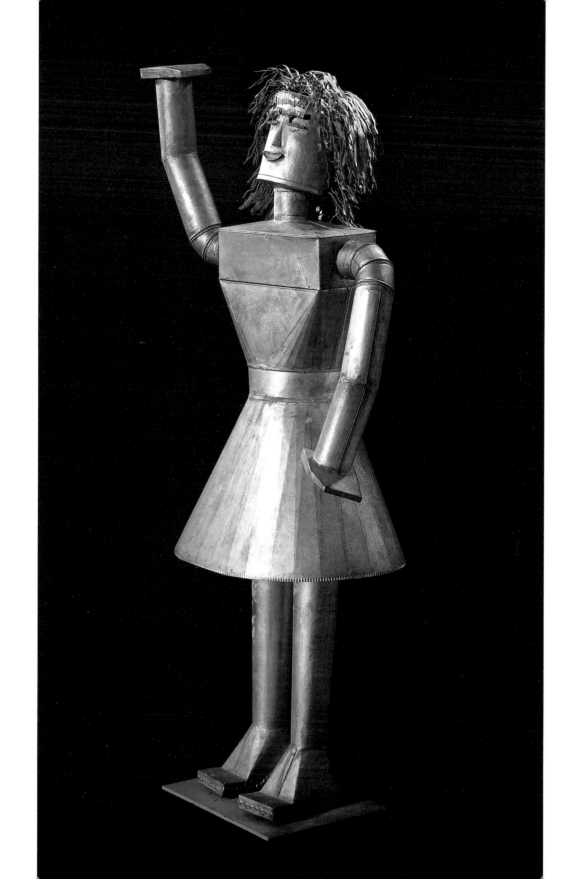

## JOSEPHUS FARMER

1894–1989

# *Samson*

1982
painted redwood
with rhinestones
69.6 x 70.5 x 3.9 cm
Smithsonian
American Art
Museum, Gift of
Herbert Waide
Hemphill Jr. and
museum purchase
made possible by
Ralph Cross Johnson

At the center of this painting stands a tiny Lamb of God next to a white cross. This image is surrounded by six scenes from the Old Testament. Samson slays the lion in one vignette, and in another points to his hair, revealing it as the source of his strength. Delilah, who revealed his secret and will destroy his strength, stands behind him. Other scenes depict the story of the fall in Genesis.

Farmer was called to the Pentecostal ministry in 1922, when he was in his late twenties. Beginning as a street preacher, he established churches in Kinlock, Missouri, and Milwaukee, Wisconsin, while he worked as a laborer to support his family. He had learned the rudiments of wood carving as a child, and began producing panels to use for religious instruction in the early 1950s; at about the same time he began painting evangelistic banners. Although he also carved and painted three-dimensional tableaux, he is primarily known for painted relief carvings like this.

Samson

EHOLD THE ... Lamb of God ...

Gen c 3 v 1          The Sin of the world

## ALBINA FELSKI

1916–1996

# The Circus

1971, acrylic
122 x 122.4 cm
Smithsonian
American Art
Museum, Gift of
Herbert Waide
Hemphill Jr. and
museum purchase
made possible by
Ralph Cross Johnson

Felski's *Circus* is an exciting place. The bleachers are packed with wide-eyed spectators. Their attention is divided among eleven trapeze artists performing death-defying feats and an eight-ring circus populated by two clowns, a couple of prancing zebras, an equestrienne wearing a Native American war bonnet, a gaily dressed woman cavorting with elephants, and three animal-tamers performing with lions, leopards, and bears.

The circus—an entertainment form whose populist nature parallels that of vernacular art itself—has been a source of inspiration for a number of twentieth-century artists, perhaps most notably Alexander Calder, the American engineer-turned-sculptor known for his colorful mobiles. Felski's painting is the two-dimensional equivalent of Calder's whimsical work of the same name. A transplanted Canadian, Felski was a forty-four-year-old worker in an electronics factory when she took up painting.

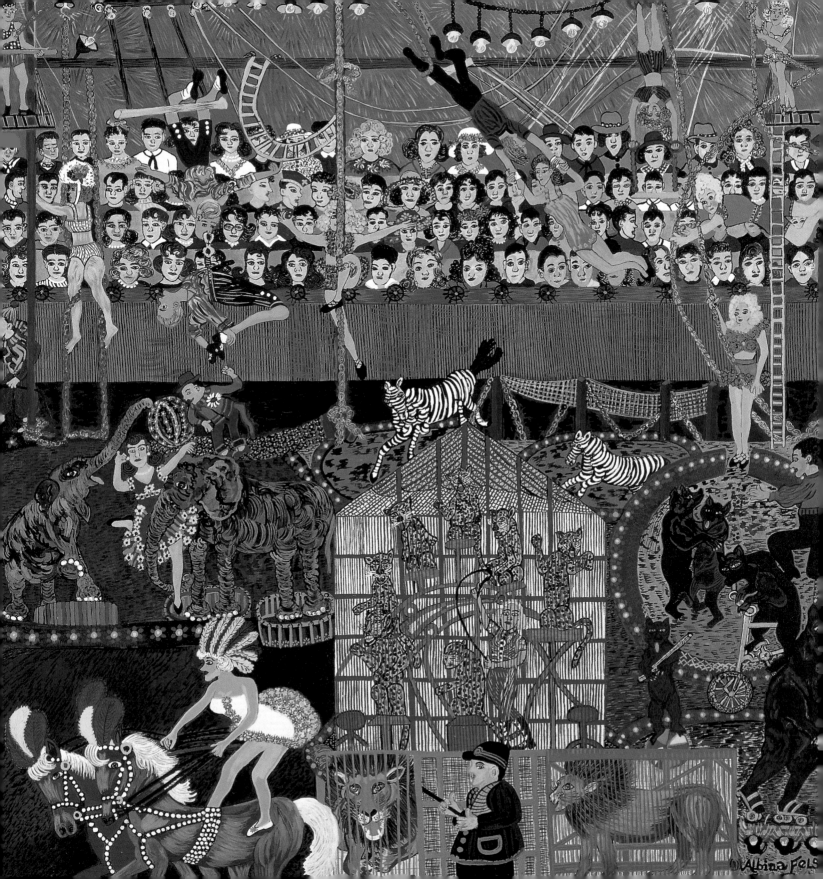

**HOWARD FINSTER**

born 1916

## *The Herbert Wade Hemphill Jr. Collection Founder of American Folk Art The Man Who Preserves the Lone and Forgotten. The Unknown Collection*

1978, enamel
on plywood
201.9 x 126.9 cm
Smithsonian
American Art
Museum, Gift of
Herbert Waide
Hemphill Jr. and
museum purchase
made possible by
Ralph Cross Johnson

Herbert Waide Hemphill Jr. was undoubtedly the most enthusiastic and influential collector of twentieth-century folk art. He commissioned this portrait in 1978, by which time Finster had made more than one thousand numbered and dated works, and had a national reputation as an artist. He worked from a snapshot of Hemphill, and painted this full-length portrait in his bold signature style. A casually clad Hemphill poses against a background of books. Since Finster was apparently unaware that Hemphill collected books as avidly as he did art, this was a prescient choice. Finster's high opinion of his patron is clearly expressed in the title of the painting, while the texts on the book covers convey his religious and moral ideas.

Finster, a handyman-preacher-turned-artist, had been working on his two-and-a-half-acre Plant Farm Museum and Paradise Garden for fifteen years when a mystical experience inspired him to take up painting in 1976. His distinctive work quickly drew the attention of collectors and curators. Typically early on the scene, Hemphill was at Finster's place in Pennville, Georgia, within months of that pivotal career decision, and commissioned this work on a later visit.

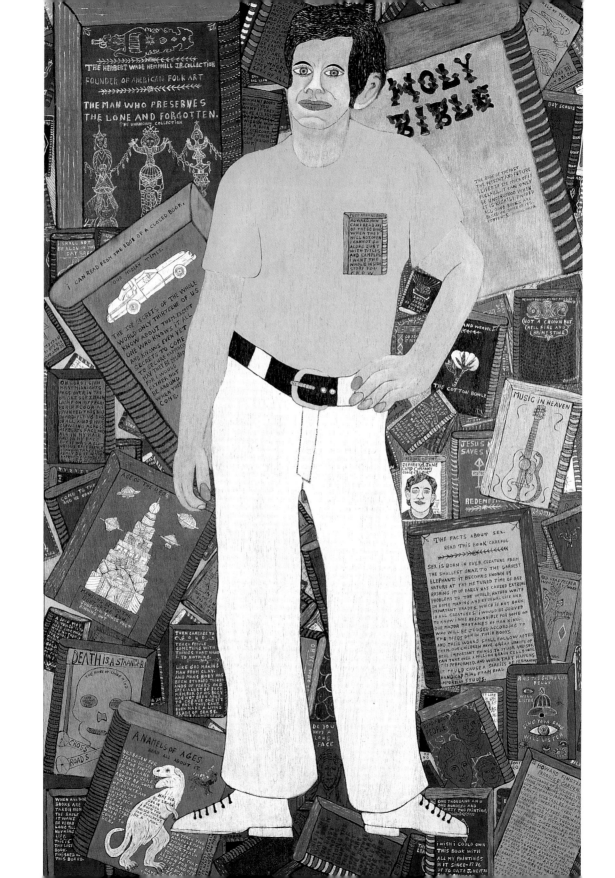

**HOWARD FINSTER**

born 1916

## The Lord Will Deliver His People across Jordan

1976, enamel
76.4 x 75.1 cm
Smithsonian
American Art
Museum, Gift of
Herbert Waide
Hemphill Jr.

Christ stands with open arms, ready to carry poor sinners across the River Jordan and welcome them to his eternal kingdom. In the foreground, texts enumerate the calamities, conflicts, iniquities, and suffering that characterize our mortal life, while the promised land is clearly visible beyond the blue water. Pathways labeled "Kindness," "Love," "Peace," "Eternal Life," and "Hope" lead to heavenly mansions crowned with spires and turrets, while angels hover in a cloud swept sky. The landscape and architecture of this "heaven" are early manifestations of imagery that became a standard feature in many of Finster's paintings. Painting for less than a year when he created this visionary landscape, Finster hung it on an exterior wall of his bicycle-repair shop near his environment of cement sculptures and assemblages. Finster often called his works "sermons in paint." He built several three-dimensional models of buildings like the ones in this painting; the ornate, tiered *World's Folk Art Church* that he later erected on his property can be considered a full-scale version of this early vision.

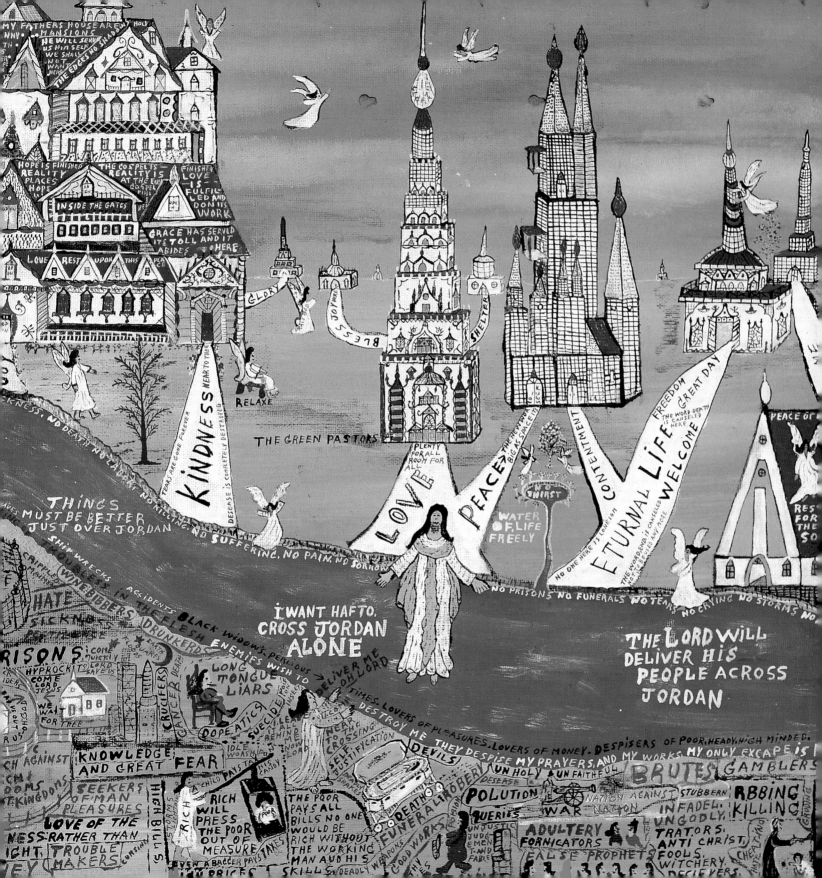

**HAROLD GARRISON**

born 1923

# *Water Gate or Government Machine*

1974, ink on wood
with leather and metal
34.8 x 38 x 9 cm
Smithsonian
American Art
Museum, Gift of
Herbert Waide
Hemphill Jr. and
museum purchase
made possible by
Ralph Cross Johnson

The Republican elephant and the Democratic donkey, both labeled "clowns," stand back to back on a seesaw. When the trigger is pulled, the donkey ascends, the elephant descends, a monkey spins, and the door of the "bug house" opens to show a tiny compartment full of spotted beetles. This cleverly devised kinetic sculpture is a three-dimensional political cartoon about one of the political scandals of the 1970s—the burglary of the Democratic National Committee at the Watergate Hotel. Words printed on the "barrel" of this "Watergate gun" admit it "don't really do anything of value," but "show[s the politicians in] Washington how little they do."

Like many of his neighbors in Southern Appalachia, the independent Garrison takes a skeptical view of Washington politics. This work, which has elements of a Rube Goldberg cartoon, belongs to a series that includes an equally satirical piece about the 1972 Democratic convention.

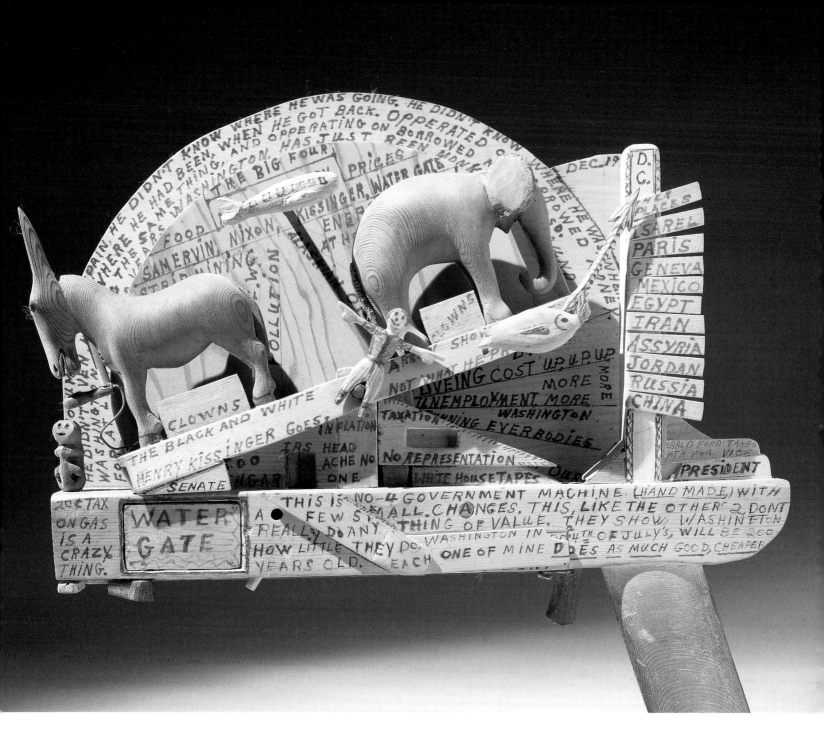

**LOUISE GOODMAN**

born 1937

# *Bear*

1990, fired clay
with piñon pitch
56.5 x 27 x 27.6 cm
Smithsonian
American Art
Museum, Gift of
Chuck and Jan
Rosenak and
museum purchase
made possible by
Mrs. Snowden A.
Fahnestock

With his enlarged body and tiny limbs, this bear is undeniably whimsical. Goodman's bears invariably stand on their hind legs; the striated surfaces that give the impression of thick fur are also typical. Goodman's choice of the bear as subject may reflect the status of this powerful animal as an emblem of power and plenty. For centuries the bear was a source of food, clothing, and ceremonial implements for the Navajo.

A contemporary exponent of a long-standing Navajo pottery tradition, Goodman first made simple vessels until the 1980s. As demand for functional works declined, she began to make small animal figurines as children's toys—and enlarged the usual scale of those figurines to begin creating sculptures such as this one. Sometimes Goodman puts a small slot in the backs of her figures so they can be used as coin banks.

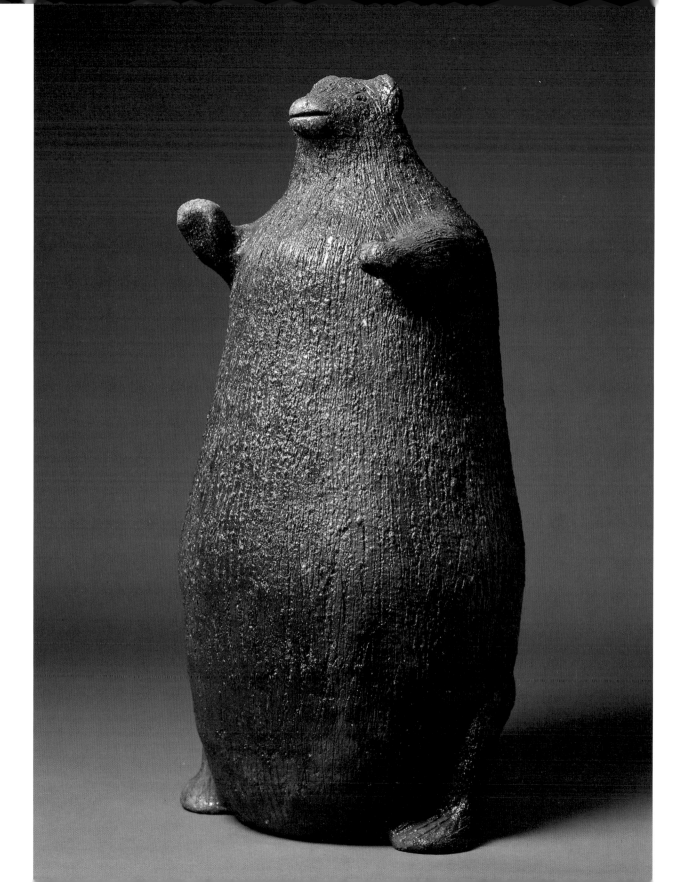

**WILLIAM HAWKINS**

1895–1990

# *Ohio State University Stadium*

1984, enamel
housepaint on
paneling
117.9 x 121.7 cm
Smithsonian
American Art
Museum, Gift of
Herbert Waide
Hemphill Jr. and
museum purchase
made possible by
Ralph Cross Johnson

Seen from the air, the stadium of the university in Hawkins's adopted hometown of Columbus, Ohio, is painted in bright colors and with distinguishing details on a salvaged piece of wood paneling. Hawkins nearly always based his paintings on a printed image that caught his eye, but they are never simply copies.

This is one of more than five hundred paintings Hawkins is known to have made after 1981, when his work began to gain public attention. He claimed to have been drawing since his childhood in rural Kentucky. During the 1930s and '40s he occasionally sold a few small works, but he became much more productive when he retired in the late 1970s. By that time he had been living in Columbus for more than sixty years, and he took special pleasure in painting that city's architecture. He was also fond of painting historical scenes and monumental pictures of animals, most often on salvaged wood.

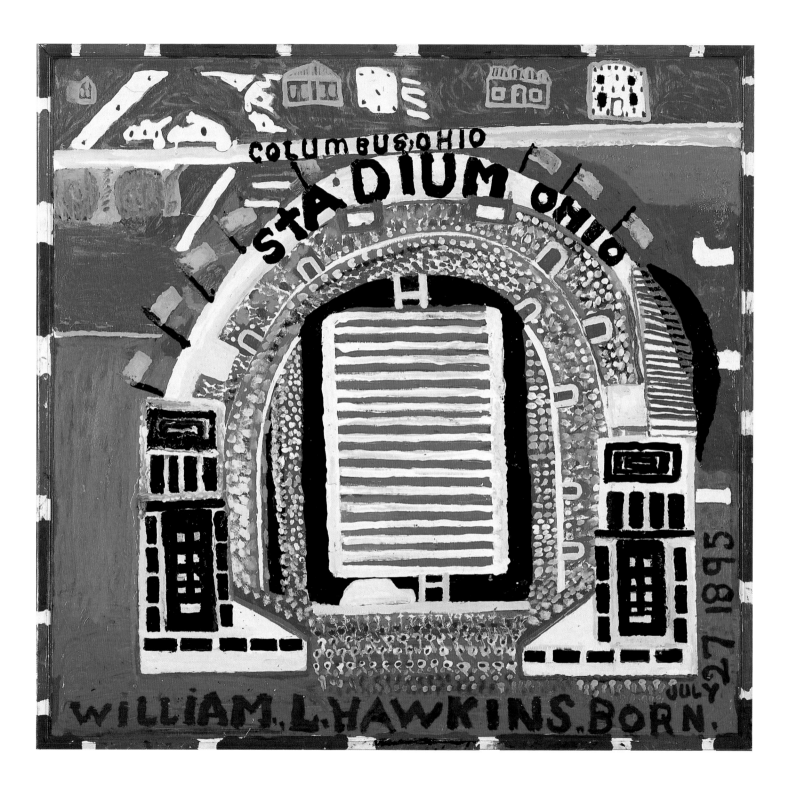

**JESSE HOWARD**

1885–1983

# *The Saw and the Scroll*

1977–78
acrylic and crayon
on canvas, wood,
and metal
101 x 180.3 x 3.8 cm
Smithsonian
American Art
Museum, Gift of
Chuck and Jan
Rosenak and
museum purchase
through the Luisita L.
and Franz H.
Denghausen
Endowment

Covered edge to edge with neatly lettered text, this piece begins with a personal introduction and ends with a description of the spring day when it was completed, but otherwise it functions almost entirely as a sermon. The text, which covers the canvas and the saw blade, is a list of Biblical citations and an exhortation to read and live by the Bible. Significantly, the cross-cut saw aligns with the panel to form a cross. In one sense, the saw also encapsulates the entire Bible, with citations that begin with the book of Genesis and conclude with The Revelation of Saint John the Divine.

Soon after Jesse Howard purchased twenty acres for a home in Fulton, Missouri, he began using it to air his religious, political, and philosophical convictions. He posted signs covered with neat, hand-lettered texts. Unfortunately Howard's neighbors were not pleased with his contributions to the public debate. From the late 1940s until the 1970s, "Sorehead Hill"—as he called his place—was frequently vandalized, and he was repeatedly harassed for his unconventional means of exercising his "free thought and free speech." In 1952 some of his neighbors even went so far as to circulate a petition demanding that he be committed to a mental institution. Embittered but hardly broken by such vicissitudes, Howard remained determined to express himself, and he was eventually rewarded with favorable attention from scholars, collectors, dealers, and curators. This later work has a more relaxed tone than some of his earlier signs, which were essentially rants against specific government officials and the vandals to whom his work often fell victim.

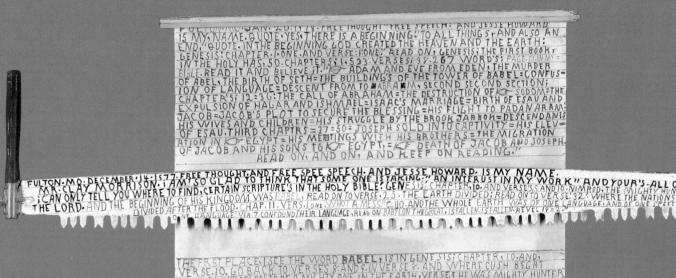
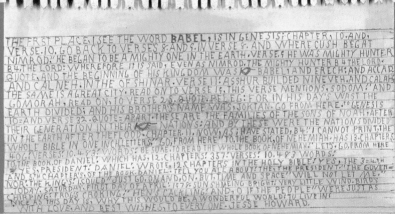

**MR. IMAGINATION**

born 1948

# Bottlecap Figure with Mirror

1991, bottlecaps
and mirror on wood
151.8 x 61 x 28.6 cm
Smithsonian
American Art
Museum, Gift of
Chuck and Jan
Rosenak and
museum purchase
through the Luisita L.
and Franz H.
Denghausen
Endowment

This jaunty figure, covered with bottle caps, is a signature piece for a Chicago artist long known as Mr. Imagination. This sculpture is a regal self-portrait, though the mirror embedded in his torso is an unusual touch—with it he catches our eyes and draws us into the work.

Folk artists have long used bottle caps to bring texture and color to their works, and Gregory Warmack, or "Mr. I," as he prefers to be called, has taken this practice to a new level. A native Chicagoan, Mr. Imagination began to carve figures from found pieces of industrial sandstone (a by-product of steel manufacturing) during the early 1980s. As his work attracted attention, he began to use another salvaged material—bottle caps—toward the end of the decade. Warmack excels at turning discarded materials from the streets and alleyways of his hometown into art, and transforming the castoffs of contemporary society into celebrations of his unique identity.

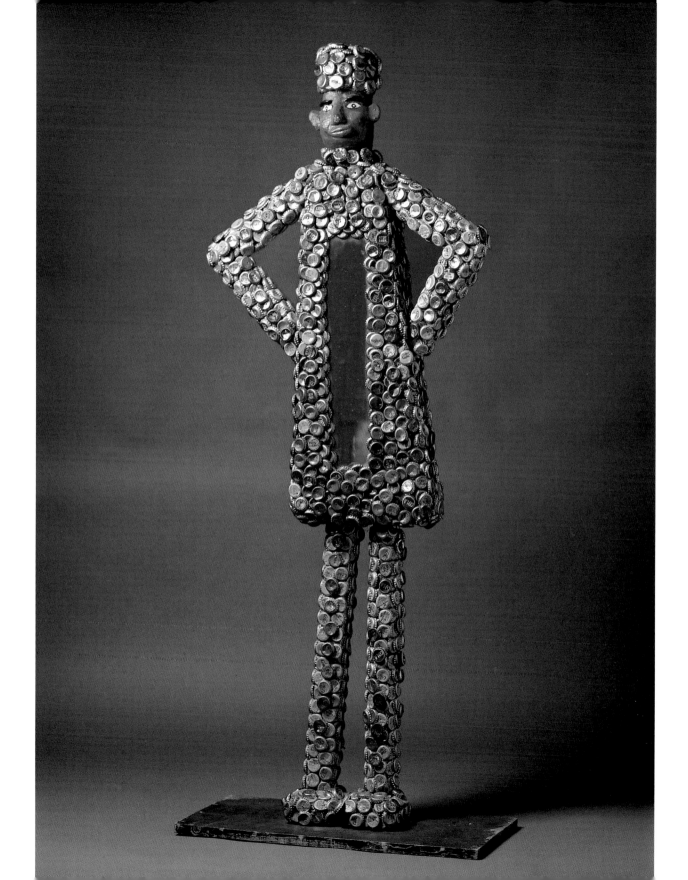

## SHIELDS LANDON "S.L." JONES

1901–1997

# Country Band

1975–76
painted wood
Smithsonian
American Art
Museum, Gift of
Herbert Waide
Hemphill Jr. and
museum purchase
made possible by
Ralph Cross Johnson

a) Fiddler
59 x 20 x 19.3 cm
b) Guitarist
63.4 x 23.5 x 18.8 cm
c) Banjoist
64.8 x 27.9 x 22.5 cm

A fiddler, guitar player, and banjo player are caught at a moment of intense concentration. They stand ramrod straight, and their hands have just left their instruments, perhaps as they listen for applause from the audience. Jones was depicting a moment he knew well—as a youngster he had been a prize-winning fiddler, as well as a self-taught wood-carver.

Following the death of his first wife in the late 1960s, Jones coped with his grief by resuming two favorite activities of his childhood—playing Appalachian-style music and "whittling" wood. For years he fiddled primarily for his own entertainment and that of his second wife, whom he married in 1972. But over time he became more ambitious in his wood carving. Evolving within a few years from small, unpainted wildlife figures like those he had carved as a child to busts and heads of people and animals, his efforts culminated in the painted, freestanding figures that he made for roughly fifteen years beginning in the late 1960s.

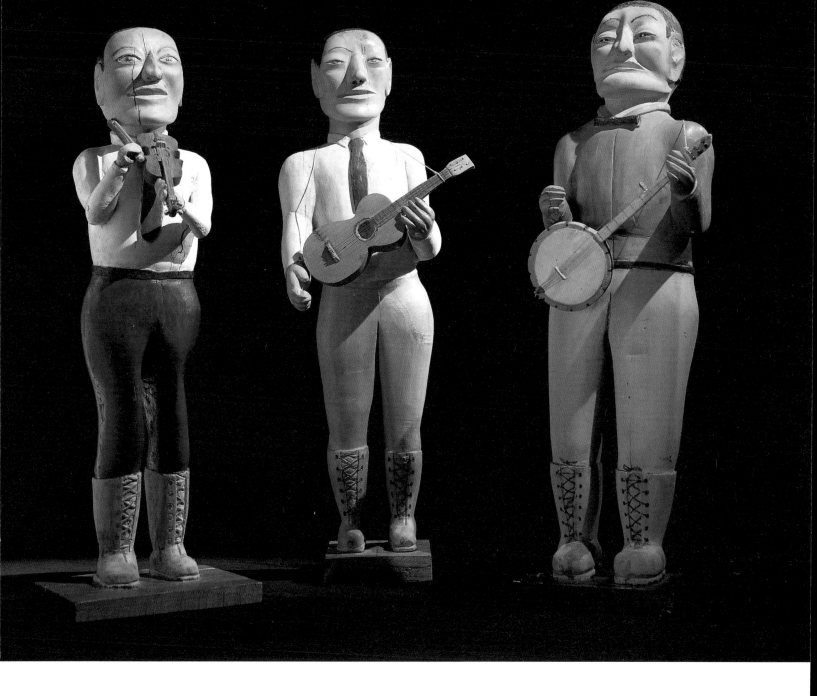

**EDWARD A. KAY**

1900–1988

## *Gerald Ford Totem Pole*

1974, painted wood
and metal
with found objects
231.1 x 31.8 cm diam.
Smithsonian
American Art
Museum, Gift of
Herbert Waide
Hemphill Jr. and
museum purchase
made possible by
Ralph Cross Johnson

A broadly smiling Gerald Ford is seated atop the dome of the U.S.
Capitol. He wears a football uniform that recalls his college days during
the 1940s, when he played center for the University of Michigan
Wolverines. Just beneath him on this totem pole his vice president,
Nelson Rockefeller, wears the Capitol dome as a hat. He sits on top of
a stone-faced secretary of state, Henry Kissinger. At the bottom of the
pile is Richard Nixon, his eyes blanked out, his hands clamped over his
ears, and his lips firmly fastened with a safety pin.

One of more than one hundred hand-carved and painted totem
poles that Kay made and installed in the yard of his home in Mount
Clemens, Michigan, this piece is a tribute to his fellow Michigan native.
Ford's presidency lasted for the two years that remained after Nixon's
resignation, which had followed the Watergate hearings. An accompa-
nying freestanding panel—nearly as high as the totem pole and
collaged with related photos, texts, and clippings—was lost soon
after Kay made it.

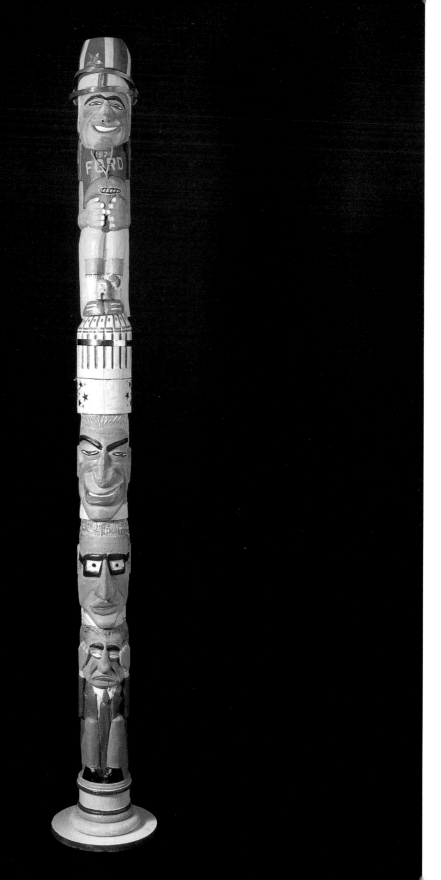

## MYRA TSO KAYE

born 1961

# *Ram Pot*

1992, fired clay
with piñon pitch
36.8 x 26 x 23.5 cm
Smithsonian
American Art
Museum, Gift of
Chuck and Jan
Rosenak and
museum purchase
made possible by
Mrs. Snowden A.
Fahnestock

The surface of this jug is adorned with small, somewhat simply stylized figures of leaping rams that recall similar animal imagery in Anasazi petroglyphs in the Southwest. In sharp contrast, the sculpted ram's head that emerges from the handle is striking in its realistic detail and reveals the artist's versatility. By combining such different variations on the same animal image in one piece, this Navajo artist celebrates her connection with prehistoric Native Americans, while arriving at a symbolic reconciliation between Native America and the nonnative cultures.

In this work Kaye combines the Navajo tradition of making small ceramic animal toys with that of creating functional pottery. Because the Navajo regard the ram as a sacred animal, Kaye inserted an offering of cornmeal in the pot's spout when she completed this piece. She learned to work with clay from her mother, Faye Tso, a well-known Navajo potter, and her father, Emmett Tso, a medicine man. She later supplemented the skills they taught her with studies in the art department at Northern Arizona State University in Flagstaff.

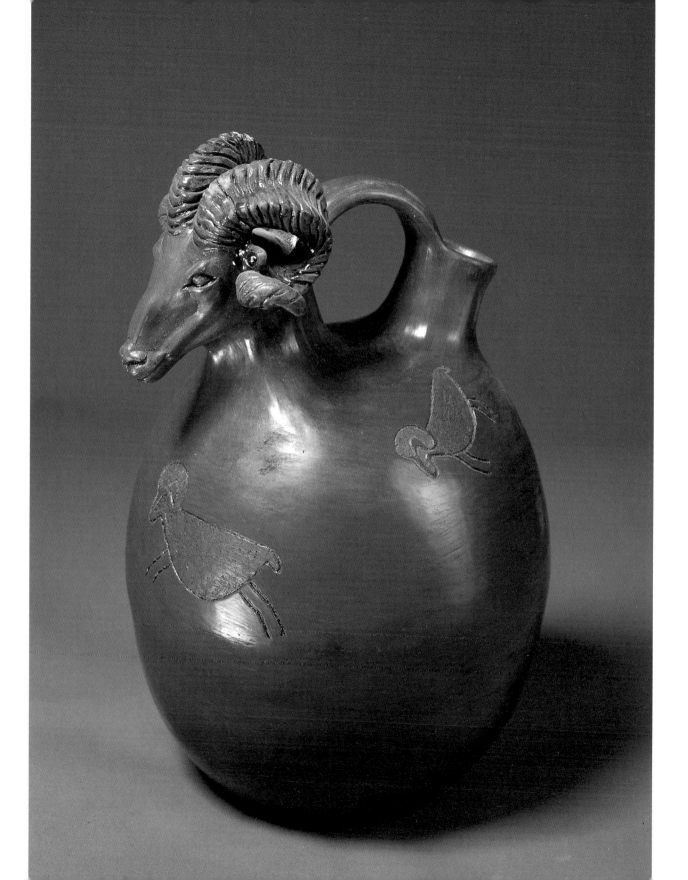

**GUSTAVE KLUMPP**

1902–1974

# *Wedding Dream in Nudist Colony*

1971, oil
61 x 76.2 cm
Smithsonian
American Art
Museum, Gift of
Herbert Waide
Hemphill Jr. and
museum purchase
made possible by
Ralph Cross Johnson

The wedding we witness in this painting is only a small part of the busy life of the nudists. More than fifty people are hiking, swimming, sunbathing, playing tennis, conversing, and embracing beneath a fluttering U.S. flag, which refers to "the land of the free" in this rural retreat for those who choose to remain free of clothing. Klumpp's clever composition achieves its balance through his use of roads and paths that simultaneously connect and divide this crowded scene.

Klumpp immigrated to the United States shortly after World War I, and was intensely loyal to his adopted country. He retired from the printing business in the late 1960s, and with encouragement from the director of a Brooklyn senior citizen center, soon began to paint. In his five-year career, he made approximately fifty paintings; nearly all of them celebrate the human nude.

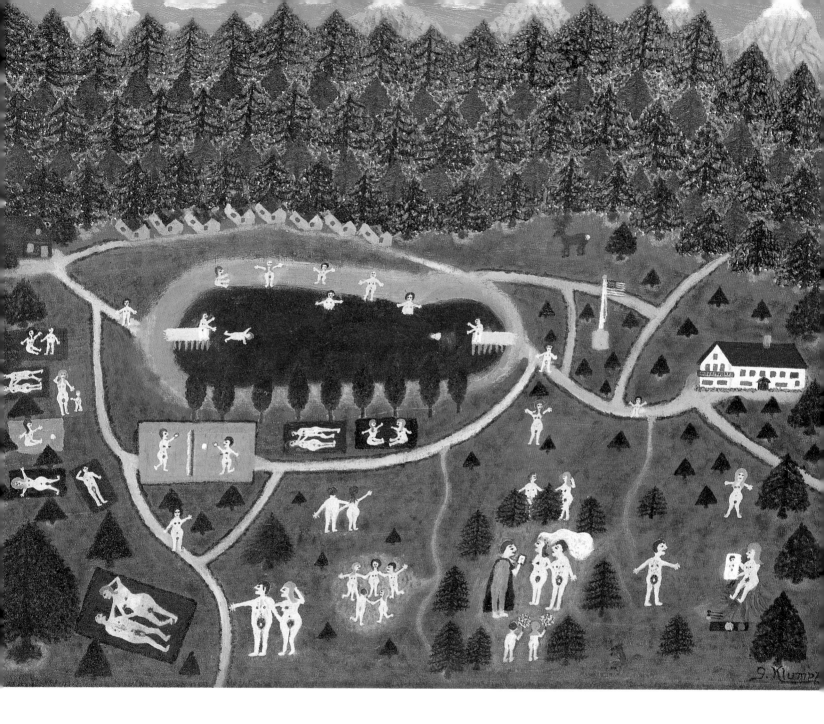

**REV. McKENDREE ROBBINS LONG SR.**

1888–1976

## *Vision from Book of Revelation*

1966, oil

112.1 x 132.1 cm

Smithsonian American Art Museum

Satan, a black-shrouded, horned figure, stands on a cloud surrounded by five avenging angels. Below, the armies of Gog and Magog are massed on the plateau overlooking the fiery lake of the Book of Revelation. The city of Jerusalem shines in the distance, just below the horizon. Satan's uncharacteristically lofty position here probably alludes to Saint John's prophecy foretelling Satan's release after one thousand years in the bottomless pit, and the global chaos that is to follow. Like many latter-day Christians, Long believed Saint John's prophecies referred to the super powers of the Cold War era, namely the United States and the Soviet Union.

As its title specifies, this visionary, panoramic bird's-eye view is based on passages from The Revelation of Saint John the Divine, the ultimate book of the New Testament, which Christian fundamentalists consider to be God's last word. During his youth, Long studied portrait painting in New York at the Art Students League and in Europe. He gave this up when he was in his early thirties to become a Presbyterian minister and evangelist. During the latter half of his life, Long painted nearly ninety visionary works on the texts of the Apocalypse, and gained a solid reputation for his "outsider" art, despite his early academic training.

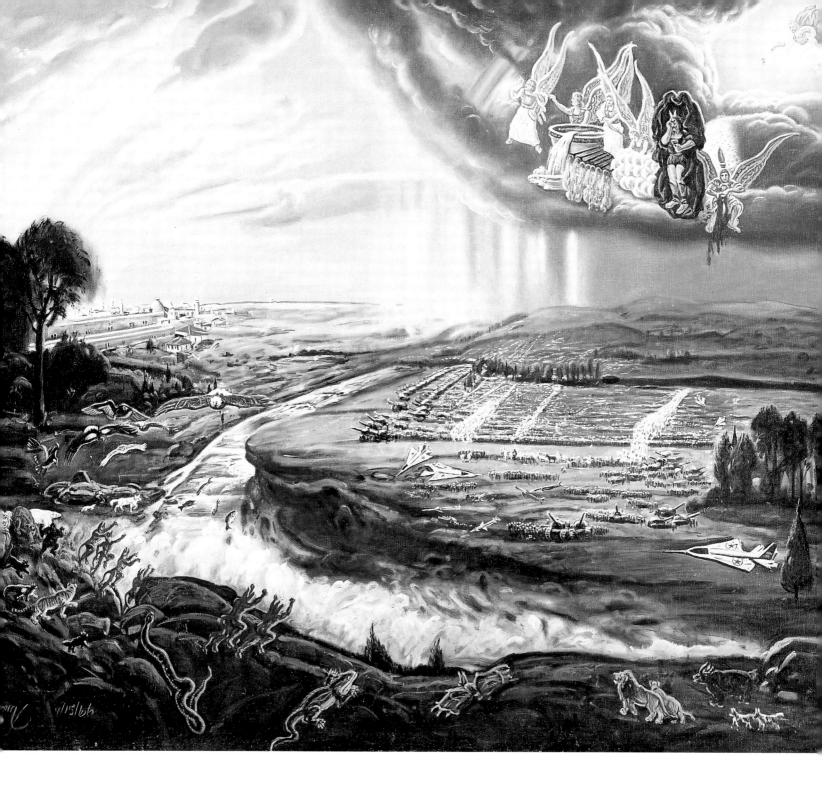

**ALEXANDER A. MALDONADO**

1901–1989

## *Waterfront at Night*
## *"Spectacular Night"*

1964, oil
54 x 69.2 cm
Smithsonian
American Art
Museum, Gift of
Herbert Waide
Hemphill Jr.

Known primarily for his paintings of spaceships and futuristic scenes, Maldonado endowed this harbor scene with a radiant, visionary quality. Searchlights, a moon, and a brilliant sky illuminate the glowing water. We enter the frame alongside the artist; we stand behind him in the bow of a boat in the center foreground. The boat cuts through the choppy waves, while a military plane crosses the sky. On the shore, the buildings are covered with dots of intense color that give them a wonderful texture. Maldonado further emphasized his illumination theme by painting a small image of an upward-shining spotlight on either of the frame's lower corners—a touch that gives the frame a stagelike quality. The setting is almost certainly San Francisco, where Maldonado lived nearly all of his life. He worked in the shipyards there until he retired at the age of sixty, when his sister encouraged him to take up painting.

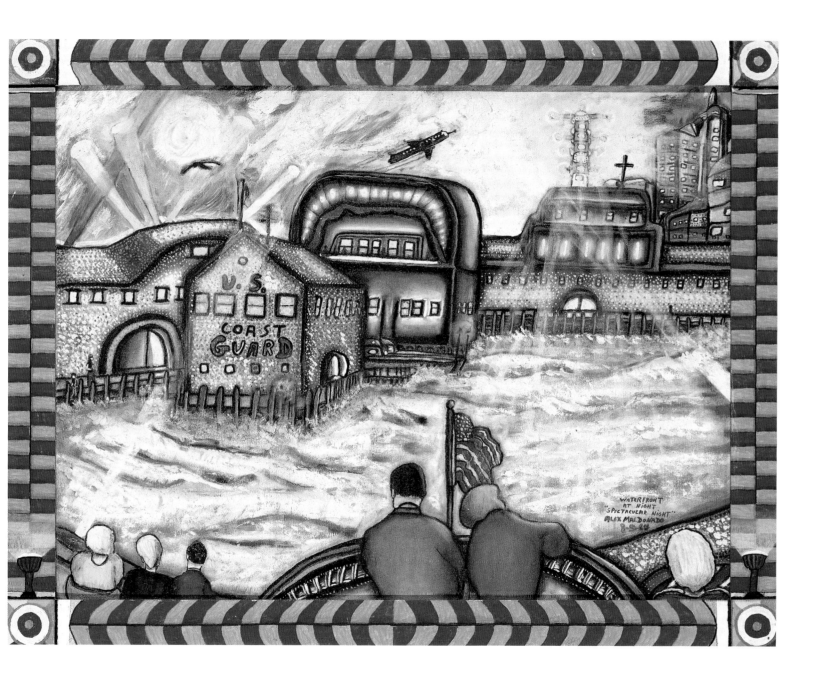

**JUSTIN McCARTHY**

1891–1977

## *Washington Crossing the Delaware, Variation on a Theme #3*

about 1963, oil
69.9 x 122.5 cm
Smithsonian
American Art
Museum, Gift of
Herbert Waide
Hemphill Jr.

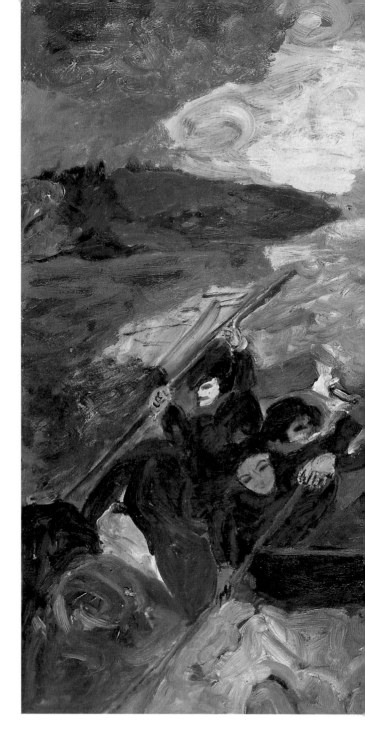

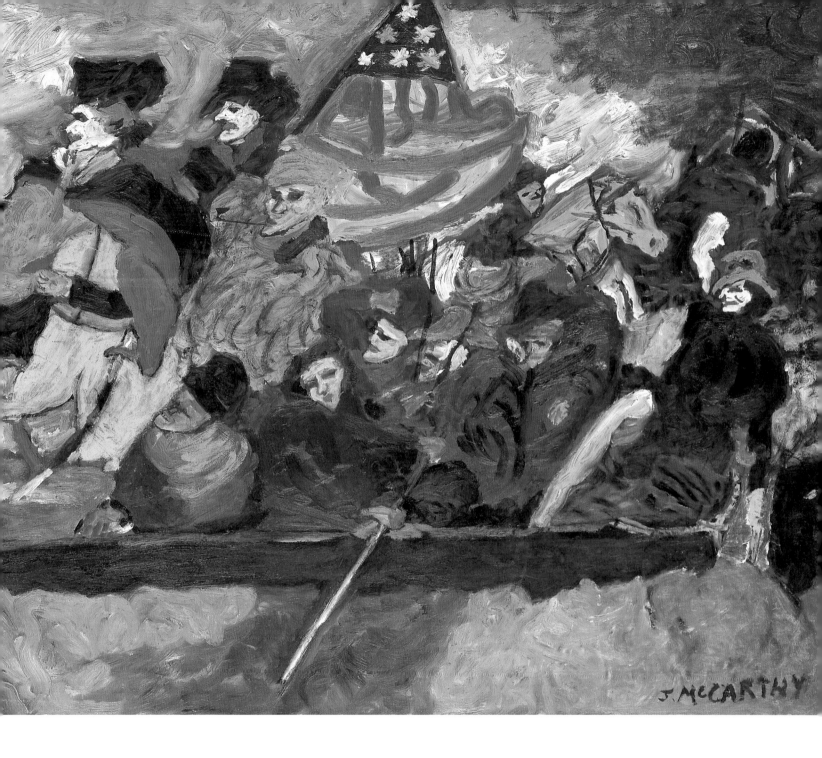

J. McCARTHY

## CHRISTINE McHORSE

born 1948

# Lizard Pot

about 1990
pit-fired clay with
piñon pitch
14.6 x 35.2 x 30.2 cm
Smithsonian
American Art
Museum, Gift of
Chuck and Jan
Rosenak and
museum purchase
made possible by
Ralph Cross Johnson

McHorse works with coils of micaceous clay from Taos Pueblo, building her pots from the bottom up, then smoothing them with river stones and adding decorative details. Here, two wide-eyed and alert lizards suggest guardian figures, their bodies and tails encircling most of the pot's circumference. The triple-stairstep patterns that rhythmically break the continuous curve of the rim echo ancient decorative motifs in traditional Southwestern pottery and architecture. In keeping with the Navajo pottery tradition, McHorse has coated this pot with piñon pitch. She sometimes fires her pots in an outdoor pit, according to Native American tradition, but she fires thin-walled pots in an electric kiln.

McHorse's work has an elegance and sophistication that defy stereotypes about folk art and traditional Native American art. McHorse began to make traditional Navajo pottery when she was in her late twenties. Having grown up off the reservation, she was introduced to the pottery craft by Lena Archuleta, her husband's grandmother. A Pueblo Indian from New Mexico's Taos Pueblo, Archuleta taught McHorse to make pots in that community's traditional style, but the younger potter soon learned the Navajo tradition and began to expand on both to develop her own distinctive approach.

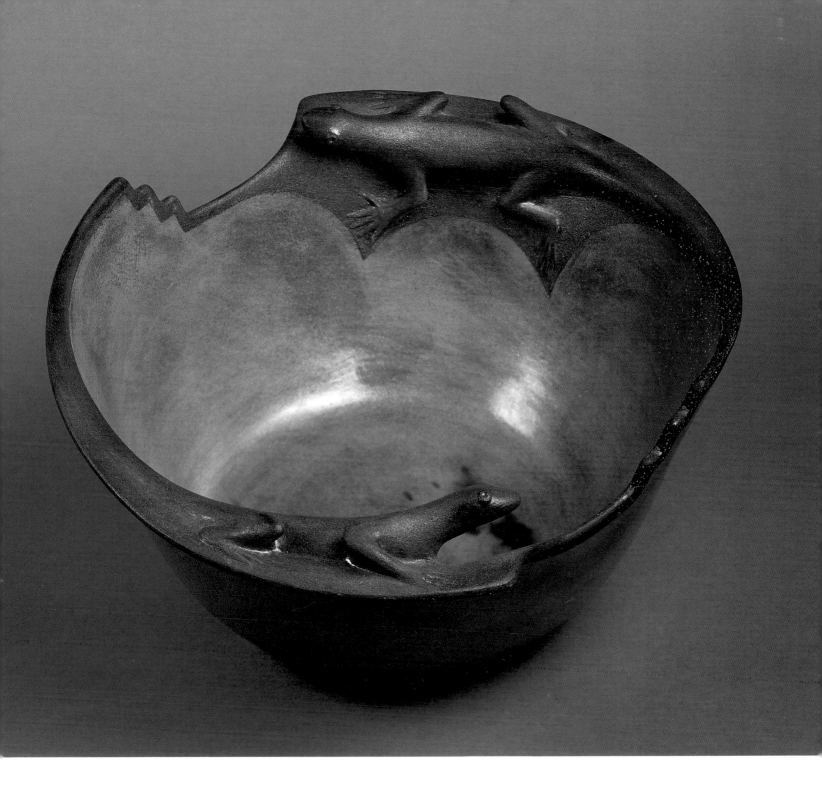

**LINDA NEZ**

active 1970s

# Carnival

1992
commercial yarn
109.3 x 146.1 cm
Smithsonian
American Art
Museum, Gift of
Chuck and Jan
Rosenak and
museum purchase
made possible by
Ralph Cross Johnson

Traveling carnivals, with their rides and midways, are a staple of American summers. This scene has all the usual elements—a Ferris wheel, rides, games, and food—set against the backdrop of Monument Valley, Arizona. The figures are dressed in traditional Navajo clothing and the only vehicles in sight are pickup trucks. The artist has departed from the strictly organized geometric designs of traditional Navajo weaving to create this busy, colorful picture.

Nez's mother was a skilled weaver of traditional Navajo rugs. Though Linda had a strong interest in the craft, her job tending the family sheep and goats left her little time to learn. Undeterred, she built her own loom and taught herself to weave. Instead of trying to imitate the traditional designs that her mother wove, she was more strongly influenced by the weaving style of her aunt, Susie Black—according to Nez, the first Navajo rugmaker to use pictorial imagery in her rugs. Nez spent four to five months painstakingly stitching her first rug, a view of the Grand Canyon. Despite the fact that collectors prefer the traditional rugs, Nez has continued to produce pictorial designs.

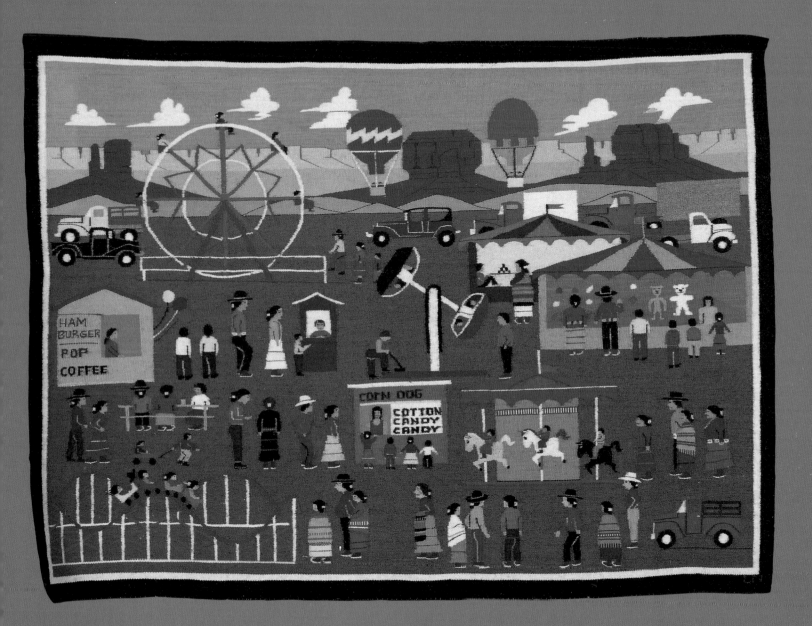

**MATTIE LOU O'KELLEY**

1908–1997

# *Farm Scene*

1975, oil
61 x 92.1 cm
Smithsonian
American Art
Museum, Gift of
Herbert Waide
Hemphill Jr.

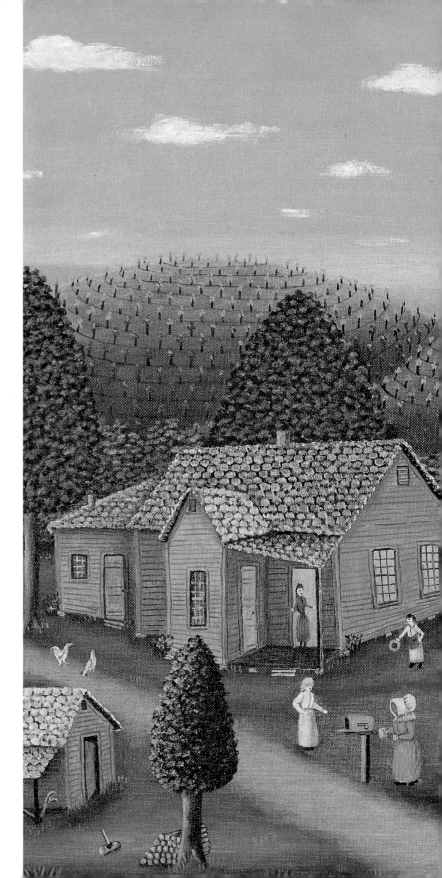

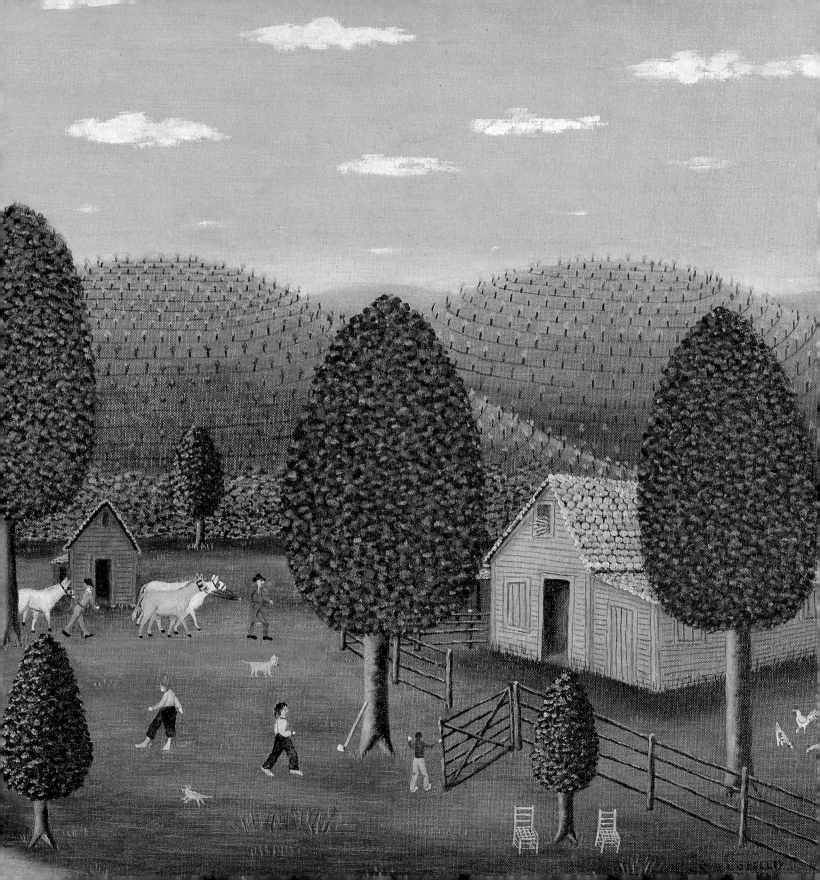

**LESLIE J. PAYNE**

1907–1981

# *New York Lady (Statue of Liberty)*

1974, painted metal
and wood with
costume jewelry
and reflector
67.7 x 41.3 x 18.8 cm
Smithsonian
American Art
Museum, Gift of
Chuck and Jan
Rosenak and
museum purchase
through the Luisita L.
and Franz H.
Denghausen
Endowment

Payne has dressed his Lady Liberty for a party. She wears a full blue skirt, bright red belt, and a low-cut yellow blouse. Her earrings dangling, she stands jauntily on her base, one hand on her hip, while the other arm holds up a bicycle reflector instead of a torch. Despite Payne's humorous liberties with his subject, she remains recognizable as a tribute to Frederic Auguste Bartholdi's *Statue of Liberty,* given by the people of France to America in 1884.

Payne was reputedly inspired to create this fanciful rendition of the famous statue by his memory of seeing the original during a bus trip he once made to New York. After living in New Jersey and Baltimore during his early adult life, Payne returned at forty to his native Virginia, where he made a living as a handyman while devoting much of his spare time to building large- and small-scale airplane models from found materials. They were displayed in an elaborate yard show that included model boats, hand-painted commemorative signs, and whirligigs. Payne was deeply interested in machinery of flight, but he also loved ornament, as evidenced by the jewelry adorning his New York Lady.

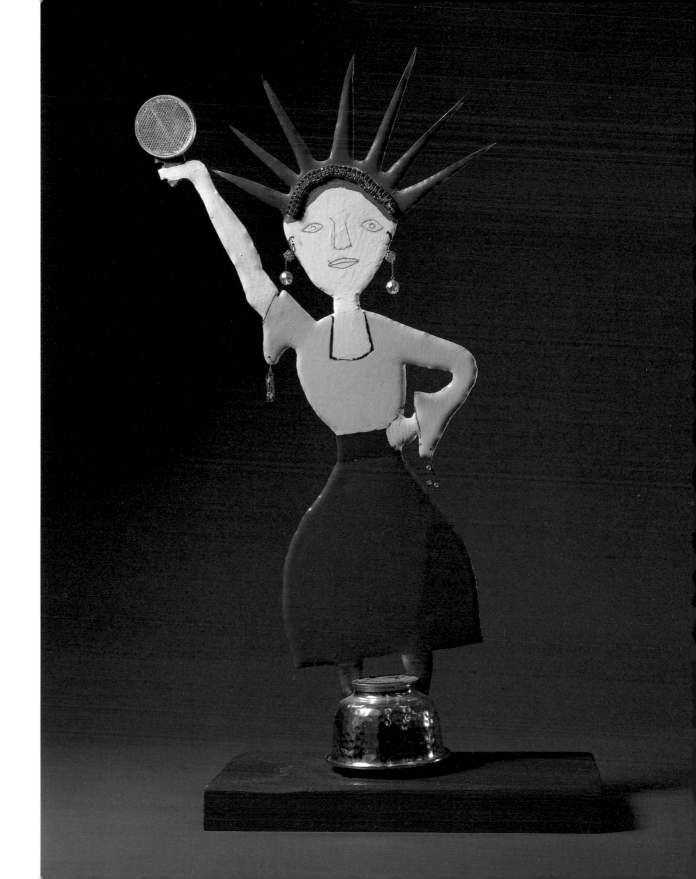

**FANNIE PETE**

born 1958

## *Pig*

about 1987
handspun wool
84.4 x 67.9 cm
Smithsonian
American Art
Museum, Gift of
Chuck and Jan
Rosenak and
museum purchase
made possible by
Ralph Cross Johnson

"It's easy to make a rug from a pattern supplied by a trader," this decidedly nontraditional Navajo weaver has said, "and I have done it on order. But what I feel I must do is make rugs from my imagination—rugs that have never been made before."

Pete's comments reflect the economic realities faced by Native American craft artists, as a need to make objects for commercial purposes collides with her strong personal vision. Pete is among a growing number of younger Navajo rug makers who have chosen to produce picture rugs rather than reproduce the traditional geometric Navajo designs. In this piece, Pete seems to deliberately play on the tension between tradition and innovation in Navajo weaving. The angular red borders at the top and bottom quote a traditional Navajo motif, but the subject—literally hogging the center of the piece—is a cartoon-style pig, confident and smiling serenely.

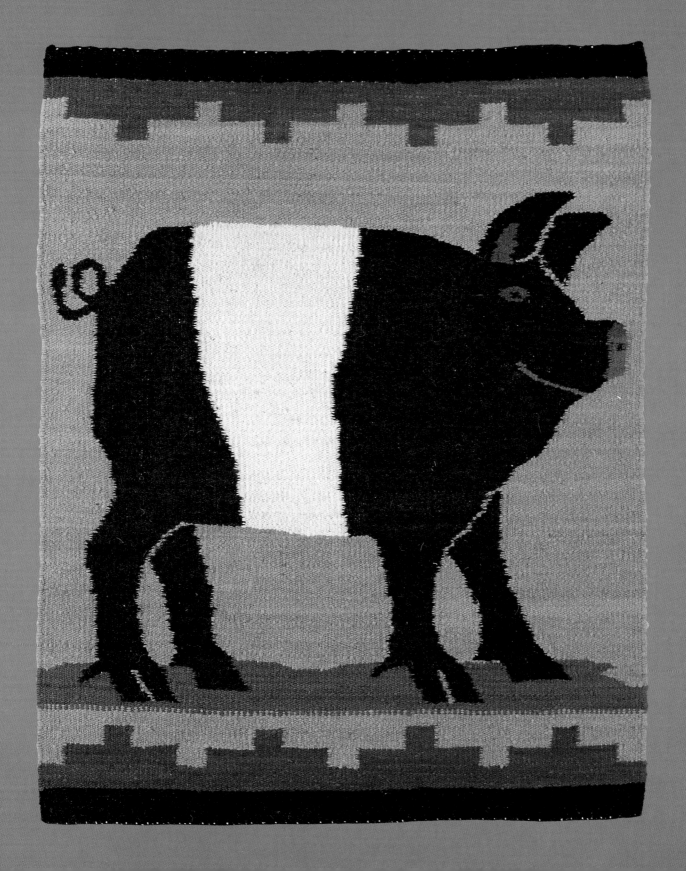

**STEPHAN POLAHA**

1891–1977

## *Winged Dog*

about 1975

painted wood with

metal and glass

45.4 x 55.9 x 26.7 cm

Smithsonian

American Art

Museum, Gift of

Chuck and Jan

Rosenak and

museum purchase

through the Luisita L.

and Franz H.

Denghausen

Endowment

Winged animals of all kinds appear as guardians in many cultures, from the Mediterranean and Europe to Indonesia and Asia. They guard everything from cathedrals, where they are frequently architectural elements, to cradles. If he was made as a part of this tradition, this charming winged dog is far more genial than fierce.

We can only speculate about the artist and his intentions, since virtually nothing is known about Polaha, beyond the fact that he lived in Pennsylvania. The carving attests to a lively imagination, which has transformed an earthbound spotted dog into a fantastical creature. The clever use of wood, metal, and glass suggests an artist who saw rich possibilities in ordinary materials.

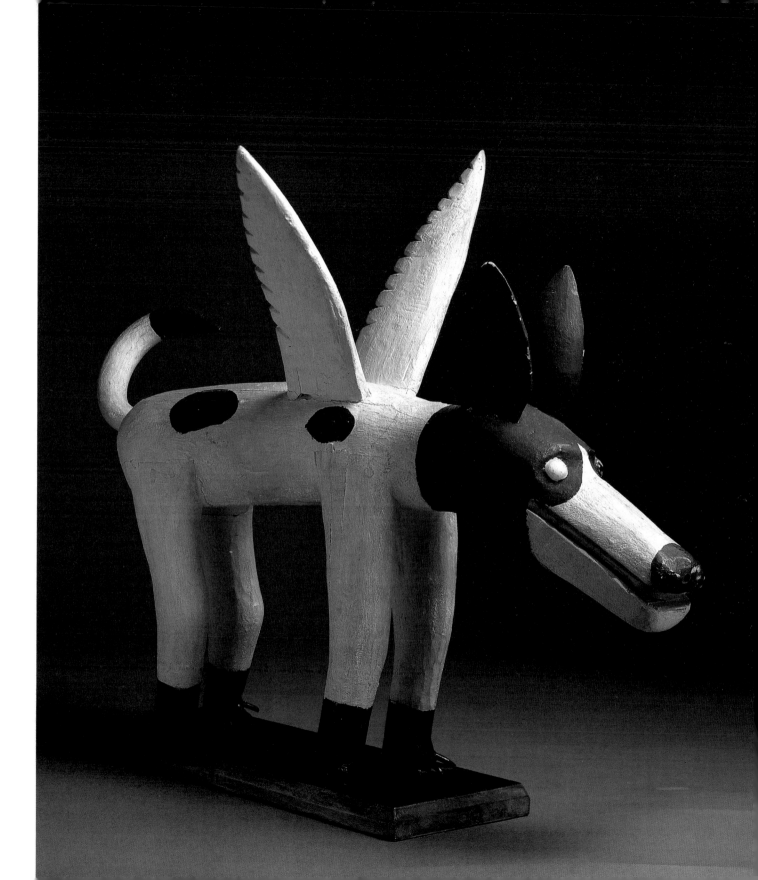

**FLORENCE RIGGS**

born 1962

# *Dinosaurs*

about 1993
commercial yarn
97.6 x 125.4 cm
Smithsonian
American Art
Museum, Gift of
Chuck and Jan
Rosenak and
museum purchase
made possible by
Ralph Cross Johnson

The striped and zigzag woven "frame" of this piece echoes the designs found in the traditional Navajo rugs made by Riggs's mother, her grandmother, and many generations of Southwestern Native Americans before them. The distant mountains and arid plain suggest an Arizona landscape, where dinosaurs indeed once roamed. But the dinosaurs are anything but traditional Navajo subjects. Riggs, like several other contemporary Navajo weavers, ignores the conventions of Navajo weaving and the long-standing Navajo taboos against secular images. Riggs probably based this composition on an illustration in a book or a popular magazine—the kind of sources she typically relies on for her imagery—but she has rendered and elaborated on in it in her own distinctive manner. By placing these long-extinct creatures within the traditional Navajo border, she may be commenting on the work of Navajo weavers who continue to make traditional rugs rather than adapting their designs to the realities of the present.

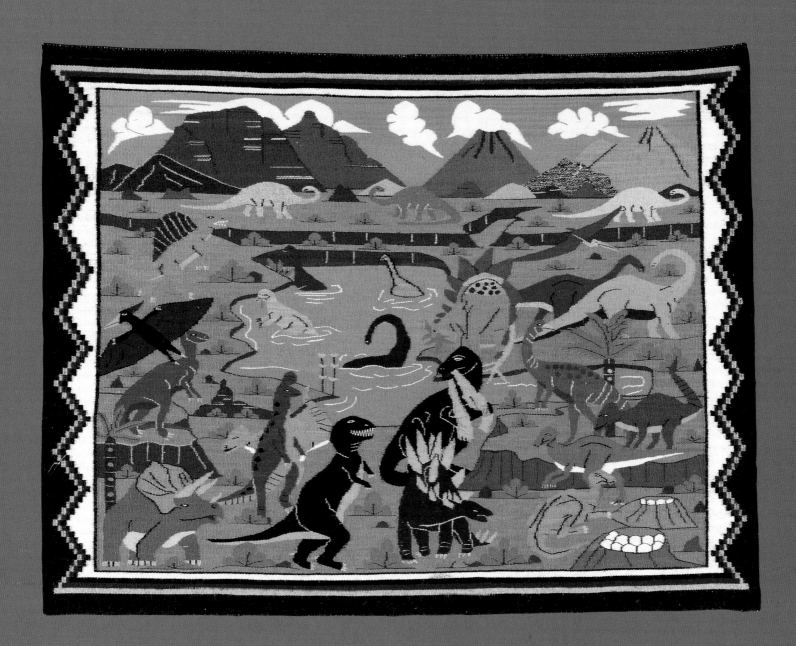

## ROBERT ROBERG

born 1943

## Babylon, the Great, Is Fallen

1992, acrylic, oil,
tempera, and glitter
101.3 x 101 cm
Smithsonian
American Art
Museum, Gift of
Chuck and Jan
Rosenak and
museum purchase
through the Luisita L.
and Franz H.
Denghausen
Endowment

Roberg depicts the Mother of Harlots as a slender blond woman tightly sheathed in a low-cut gown. With her ruby lips and toothy smile, she reminds us of a Hollywood starlet or Barbie doll, as she holds out her golden cup "full of abominations and filthiness." An angel dives through the turbulent heavens illuminated by lightning bolts and points an accusatory finger at the woman on the beast. In The Book of Revelation, Saint John describes the terrible fate of the city of Babylon, and personifies her as a woman seated on a scarlet, ten-horned beast. Roberg presents a fairly literal interpretation of Saint John's vision, though he brings to it a modern, comic-book style. The scale of this painting is too small to allow the artist to inscribe her forehead with the name Saint John saw written there ("Mystery, Babylon the Great, Mother of Harlots and Abominations of the Earth").

Roberg has preached his evangelistic message from Tennessee to Florida. He has used his paintings to illustrate his sermons. Despite the naive quality of his paintings, Roberg is widely traveled and a well-read, published poet, who earned a bachelor's degree in English in the late 1960s.

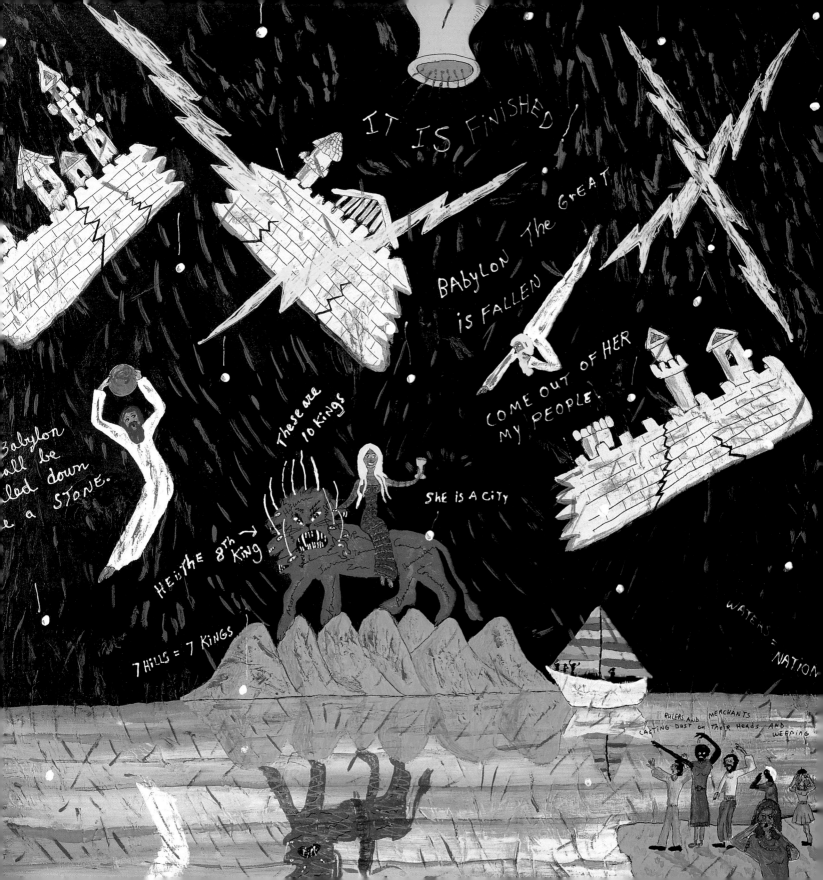

## JACK SAVITSKY

1910–1991

# *Train in Coal Town*

1968, oil
79.4 x 121.3 cm
Smithsonian
American Art
Museum, Gift of
Herbert Waide
Hemphill Jr. and
museum purchase
made possible by
Ralph Cross Johnson

Jack Savitsky grew up in "Coal Town," which was his nickname for Silver Creek, Pennsylvania. The train, with its dark smoke plume, pulls its load up a grassy hill within a border of forty identical gabled orange houses. The sameness and unending work of the company town is represented by the row of eight mill houses and the blue-gray coal breaker. Still, the sunny, storybook colors and pastoral setting give this picture of the coal-mining country where Savitsky spent his life a cheerful air.

Savitsky's father had emigrated from Russia, and his mother from Poland. Savitsky left school at the age of twelve and worked in the mines from 1916 until 1959, when the local mine was shut down. Though his work in the mines left him ill with emphysema and other ailments, it had enabled him, with only a sixth-grade education, to own his own home and support his wife and son. He chose to celebrate the coal-mining community in many of the drawings and paintings he made during the last three decades of his life. Coal-fueled trains such as the one depicted here are among Savitsky's favorite subjects, along with rural landscapes, farm and small-town architecture, and working people.

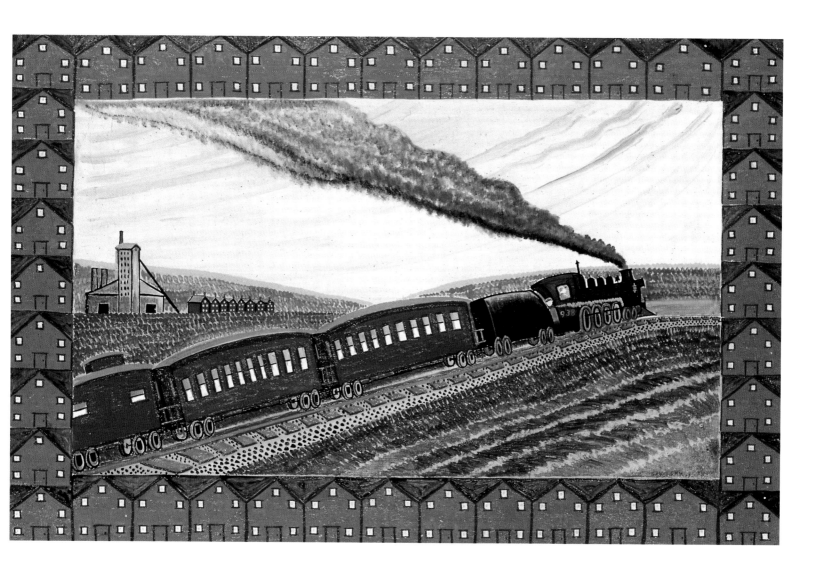

**LORENZO SCOTT**

born 1934

## *Baptism of Jesus*

1987, oil
122.3 x 122.3 cm
Smithsonian
American Art
Museum, Gift of
Jane and Bert
Hunecke

A white-clad Christ emerges from the water and sees the heavens open to reveal "the Spirit of God descending like a dove, and lighting upon him." A beam of light, representing the Holy Spirit, shines from the breast of the hovering dove on the newly baptized Jesus. Watching from above is God the Father, flanked by a dark-skinned angel who gestures toward the scene below. Joseph and Mary, along with Mary Magdalen, stand in the water with Christ and John the Baptist. Another angel, kneeling on the river shore, extends her arms toward Christ. All the figures in this picture have golden halos, which signify their purity. According to Scott, the inspiration for this painting was a vivid dream in which he witnessed the event just as he has portrayed it here.

Carefully studying Renaissance and Baroque painting through reproductions and at museums in New York and Atlanta, where he lives, Scott defies the stereotype of the folk artist as someone without knowledge or appreciation of art history. As a devout Baptist, he has often been drawn to Christian subject matter, though not all of his imagery is overtly religious. This painting depicts the immersion in water that signifies spiritual rebirth, the initiation rite for which his denomination is named.

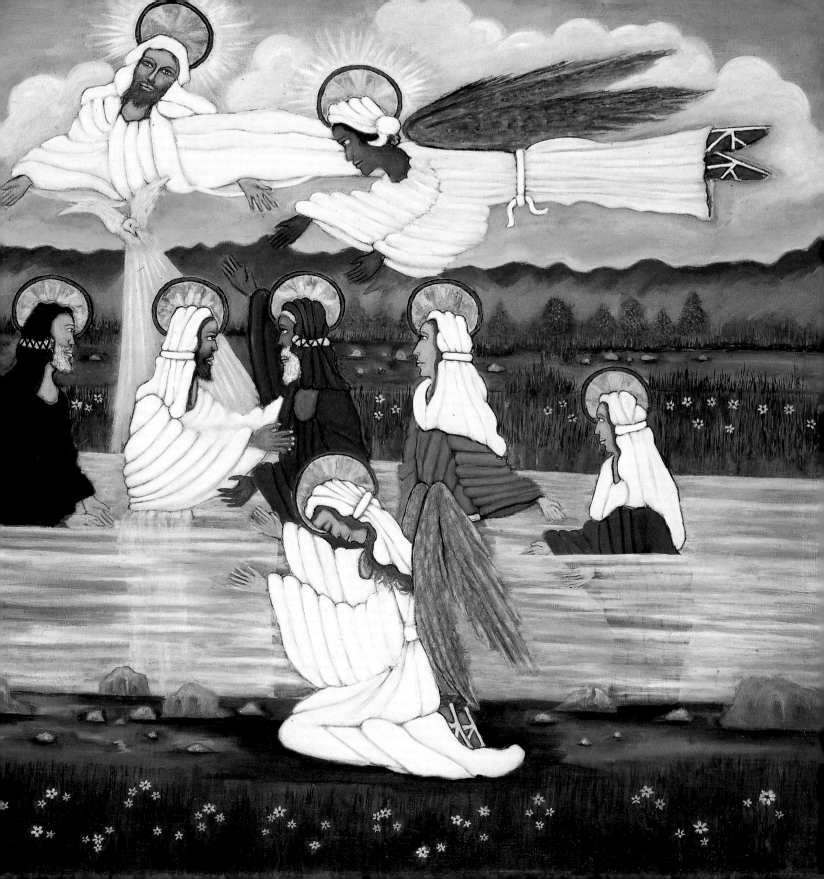

**MARY T. SMITH**

1904–1995

## *Black and Red Male Figure with Upraised Arms*

1980s, acrylic
on metal
165.7 x 67.9 cm
Smithsonian
American Art
Museum, Gift of
Chuck and Jan
Rosenak and
museum purchase
through the Luisita L.
and Franz H.
Denghausen
Endowment

With arms upraised in greeting or praise, this simple figure suggests the "praise the Lord" or "amen" gestures of worshippers in evangelical churches throughout the South. From about 1975 to 1990, Smith painted endless variations of such figures on slabs of roofing tin, and displayed them around her home in Hazlehurst, Mississippi. Many of them are self-portraits, but here the absence of articulated hair and the trousers indicate a male figure. Sometimes these images included brief texts expressing her religious faith or appealing for attention—"The Lord No Me," for example, or "Here I Am Don't You See Me." Smith was a devout Christian whose yard show functioned primarily as a physical manifestation of her faith. Her deep spirituality gave her strength to withstand the hardships of life in the Jim Crow South. Although it was gradually dismantled and sold piece by piece to collectors during the last few years of her life, Smith's yard show was a rawly expressive monument to one woman's strong spirit and creative drive.

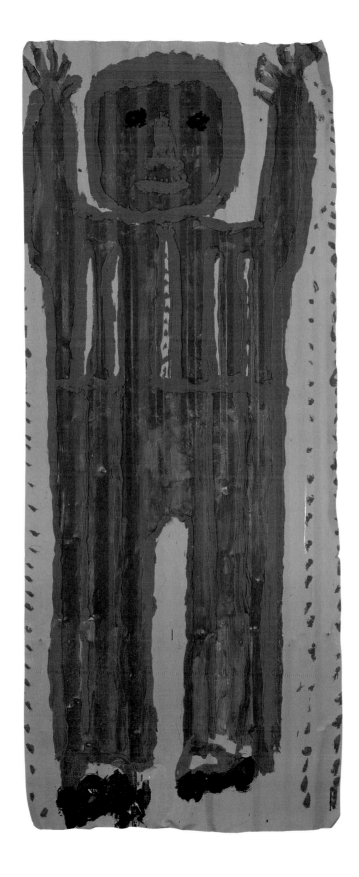

**HUGO SPERGER**

1922–1996

# *The Story of Job*

1990, acrylic
and ink on wood
124.5 x 184.8 cm
Smithsonian
American Art
Museum, Gift of
Chuck and Jan
Rosenak and
museum purchase
through the Luisita L.
and Franz H.
Denghausen
Endowment

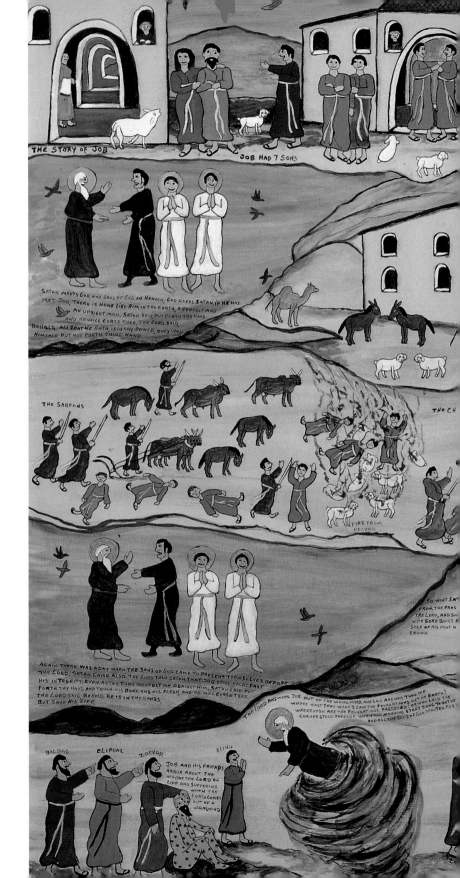

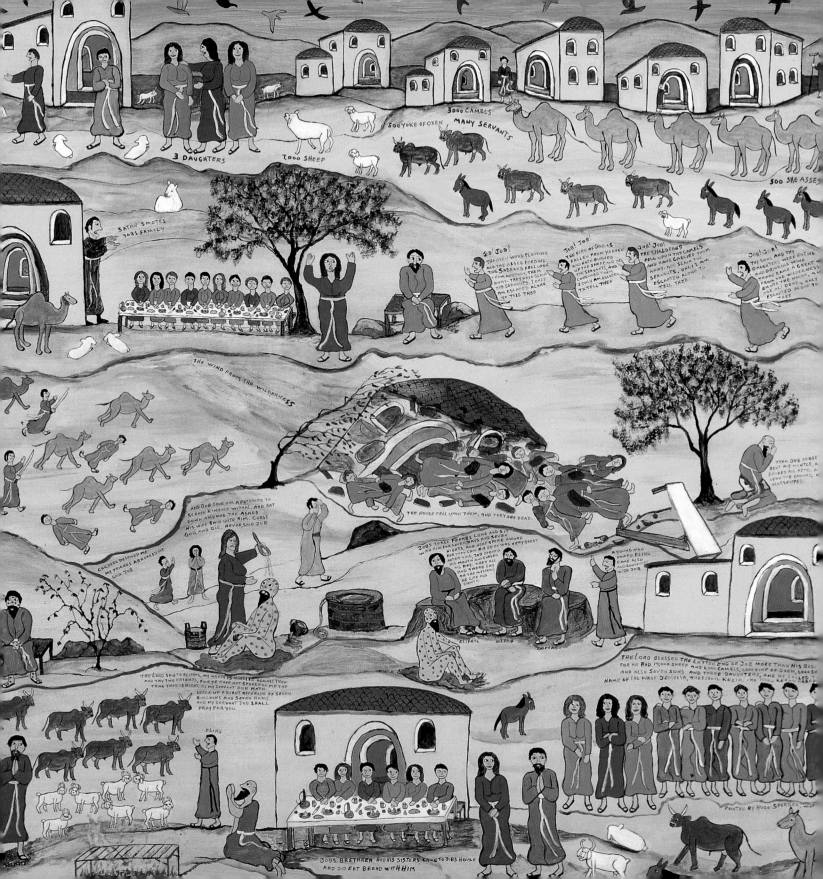

3 DAUGHTERS

7,000 SHEEP

500 YOKE OF OXEN    MANY SERVANTS

3000 CAMELS

500 SHE ASSES

SATAN SMOTES JOBS FAMILY

Job! Job! THE OXEN WERE PLOWING AND THE ASSES FEEDING THE SABEANS FELL UPON THEM AND TOOK THEM AWAY. THEY HAVE SLAIN THE SERVANTS. I ONLY AM ESCAPED ALONE TO TELL THEE

Job! Job! THE FIRE OF GOD IS FALLEN FROM HEAVEN AND HATH BURNED UP THE SHEEP AND THE SERVANTS AND CONSUMED THEM, AND I ONLY AM ESCAPED TO TELL THEE

Job! Job! THE CHALDEANS FELL UPON THE CAMELS AND HAVE CARRIED THEM AWAY, AND SLAIN THE SERVANTS, ONLY I AM ESCAPED ALONE TO TELL THEE

Job! Job! THY SONS, AND THY DAUGHTERS WERE EATING AND DRINKING, WINE AND THERE CAME A GREAT WIND FROM THE WILDERNESS AND SMOTE THE HOUSE, AND THEY ARE DEAD. ONLY I AM ESCAPED ALONE TO THEE

THE WIND FROM THE WILDERNESS

THE HOUSE FELL UPON THEM, AND THEY ARE DEAD.

THEN JOB AROSE RENT HIS MANTLE, AND SHAVED HIS HEAD, AND UPON THE GROUND, AND WORSHIPPED.

AND JOB TOOK HIM A POTSHERD TO SCRAPE HIMSELF WITHAL, AND SAT DOWN AMONG THE ASHES HIS WIFE SAID UNTO HIM, CURSE GOD, AND DIE. NEVER, SAID JOB

CHILDREN DESPISED ME, MY FRIENDS ABHORRED ME SAID JOB

JOBS THREE FRIENDS COME AND SIT WITH HIM FOR SEVEN DAYS AND SEVEN NIGHTS, AND NONE SPOKE A WORD FOR THEY SAW HIS GRIEF WAS VERY GREAT. AFTER THIS, JOB OPENED HIS MOUTH AND CURSED THE DAY. THEN ALL HAD THEIR SAY ON THE MYSTERY OF LIFE AND DEATH.

A YOUNG MAN NAMED ELIHU CAME ALSO AND CONVERSED WITH JOB

ELIPHAZ    BILDAD

ZOPHAR

THE LORD BLESSED THE LATTER END OF JOB MORE THAN HIS BEGINNING FOR HE HAD 14,000 SHEEP AND 6,000 CAMELS, 1,000 YOKE OF OXEN, 1,000 SHE ASSES AND ALSO SEVEN SONS, AND THREE DAUGHTERS, AND HE CALLED THE NAME OF THE FIRST JEMIMA, THE SECOND KEZIA, THE THIRD KEREN-HAPPUCH

THE LORD SAID TO ELIPHAZ, MY WRATH IS KINDLED AGAINST THEE AND THY TWO FRIENDS, FOR YE HAVE NOT SPOKEN OF ME THE THING THAT IS RIGHT, AS MY SERVANT JOB HATH OFFER UP A BURNT OFFERING OF SEVEN BULLOCKS AND SEVEN RAMS AND MY SERVANT JOB SHALL PRAY FOR YOU.

ELIHU

JOBS BRETHREN AND HIS SISTERS CAME TO JOBS HOUSE AND DID EAT BREAD WITH HIM

PAINTED BY HUGO SPERGER

## JIMMY LEE SUDDUTH

born 1910

## *Big City Skyline*

about 1988
paint, mud, and
sand on plywood
94 x 121.9 cm
Smithsonian
American Art
Museum, Gift of
Chuck and Jan
Rosenak and
museum purchase
through the Luisita L.
and Franz H.
Denghausen
Endowment

Sudduth's vision of northern cities is based on a trip he made to Manhattan, as well as stories of economic opportunity there. The glittering lights of a distant city brighten a vivid night sky. This archetypal city beckoned to many African Americans who left the rural South during the early twentieth century's "Great Migration," and stirred the dreams and idealism of those who remained behind.

Instead of using commercially available oils, acrylics, or enamel, Sudduth painted with a homemade mixture of dirt, water, sugar, and color extracted from weeds and vegetables. He rarely uses canvases or brushes, preferring to apply his inventive pigments to plywood panels with his fingers.

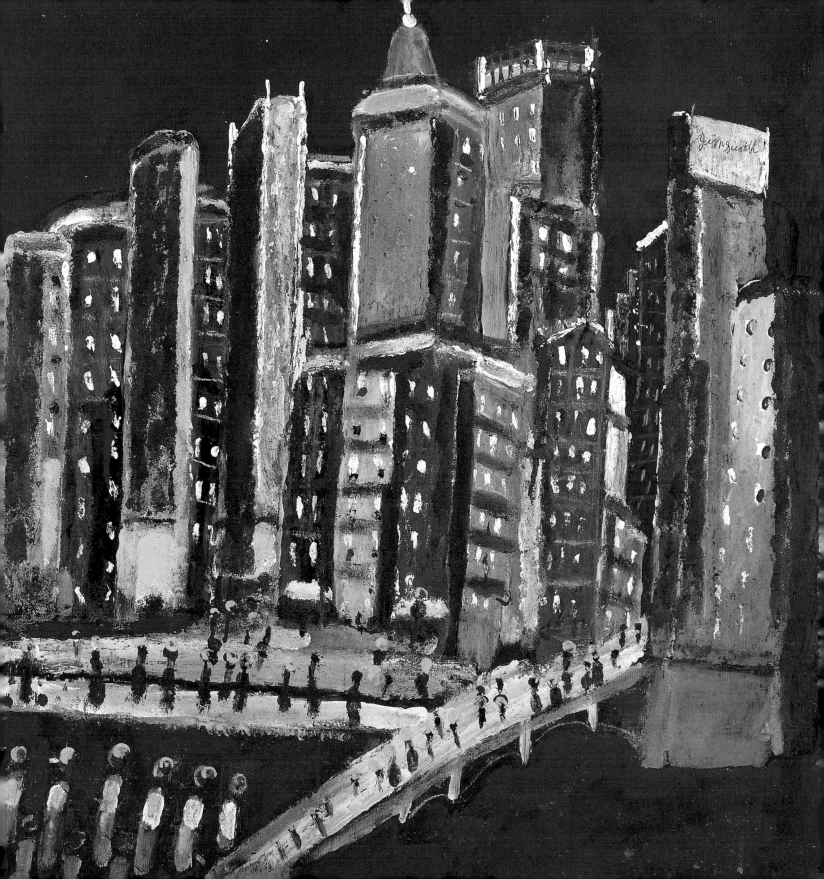

## EDGAR TOLSON
1904–1984

# *Paradise*

1968, painted white
elm with pencil
32.7 x 43.2 x 25.5 cm
Smithsonian
American Art
Museum, Gift of
Herbert Waide
Hemphill Jr. and
museum purchase
made possible by
Ralph Cross Johnson

In this tableau of Eden, the black painted snake uncoils and slithers toward the Tree of Knowledge of Good and Evil. All of the garden's other inhabitants are left unpainted, as if to signify their endangered innocence, while the serpent's movement foreshadows Adam and Eve's imminent fall from grace.

Edgar Tolson learned to whittle during his childhood and, following a stroke during the late 1950s, he returned to the practice. His early pieces were animal figures and "dolls," as he called the stylized, human effigies that he made and sold through an Appalachian crafts cooperative during the 1960s. A former preacher who admitted his extreme vulnerability to worldly temptations, Tolson might have had strong personal reasons for identifying with the story of Eve and Adam; in fact, he repeated this theme many times in his work. But he made his first Eden tableau at the request of one of his earliest collectors, John Tuska, a ceramics professor at the University of Kentucky, who wanted to see how Tolson would handle this staple subject of traditional folk art. Tolson probably completed that first example early in 1968—a smaller, starker version that included none of the birds and mammals he has added here.

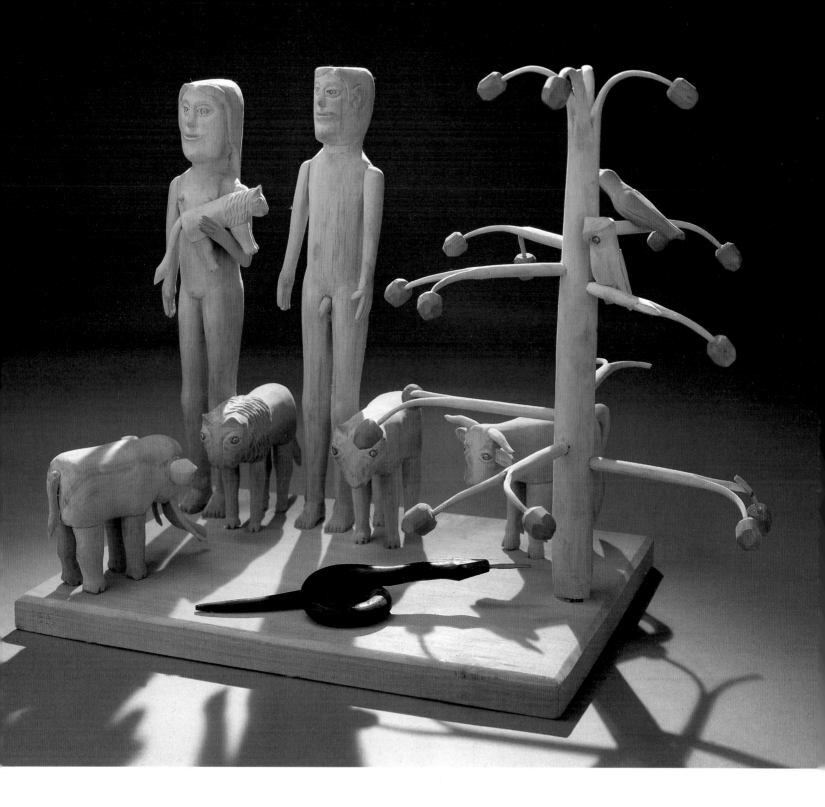

UNIDENTIFIED ARTIST

# *American Flag Whirligig*

mid-twentieth century
painted iron and wood
71.8 x 97.8 x 71.8 cm
Smithsonian
American Art
Museum, Gift of
Herbert Waide
Hemphill Jr. and
museum purchase
made possible by
Ralph Cross Johnson

Handmade windmills, weathervanes, whirligigs, and other wind-activated objects dot the American landscape, but this classic example of twentieth-century folk art is quintessentially patriotic. It lacks the figural cutouts and clever kinetic contrivances that whirligig makers love, yet its broad stripes of color, supplemented by a grid of x-shaped stars, are simple and masterfully bold. As the painted blades spin, their colors blend into concentric circles of red, white, and blue, echoing the colors of Old Glory painted on its tail.

The very simplicity that makes this object so appealing gives few clues about its maker or its original use. It dates from about the end of World War II or the beginning of the Cold War, when national feeling ran high. This whirligig may have been part of a larger outdoor display. Whether it stood alone or among a group of other handmade yard-art objects, this piece was almost certainly displayed outdoors, probably in the yard of a rural home.

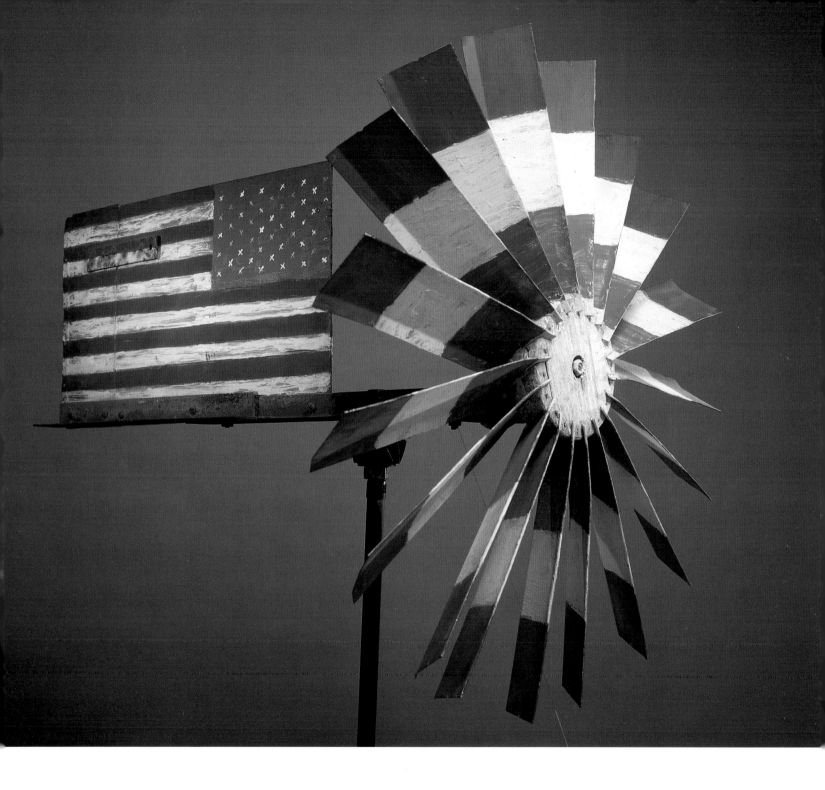

# *Bottlecap Giraffe*

completed after 1966
bottlecaps on painted
wood with marbles and
animal hair and fur
184.2 x 137.2 x 44.5 cm
Smithsonian
American Art
Museum, Gift of
Herbert Waide
Hemphill Jr. and
museum purchase
made possible by
Ralph Cross Johnson

With his head back and mouth wide open, this giraffe seems to have been captured in mid-guffaw. His mouth was originally wired so it could be opened and closed. He is covered with hundreds of colorful and once glittering bottle caps, representing more than thirty-four brands of beverages from America, Canada, and Europe. Despite his large size, he stands on a wheeled base, suggesting that the artist was interested in making a monumental version of a Victorian pull toy.

The crown cap method of sealing bottles was invented in the late nineteenth century. Distinctive for their halo of uniformly crimped points and a compact, circular form that resembles a radiant sun or star emblem, crown caps were also immediately collected for their colorful logos. Many anonymous artists have ornamented thousands of objects like this over the last century, but usually on a much smaller scale.

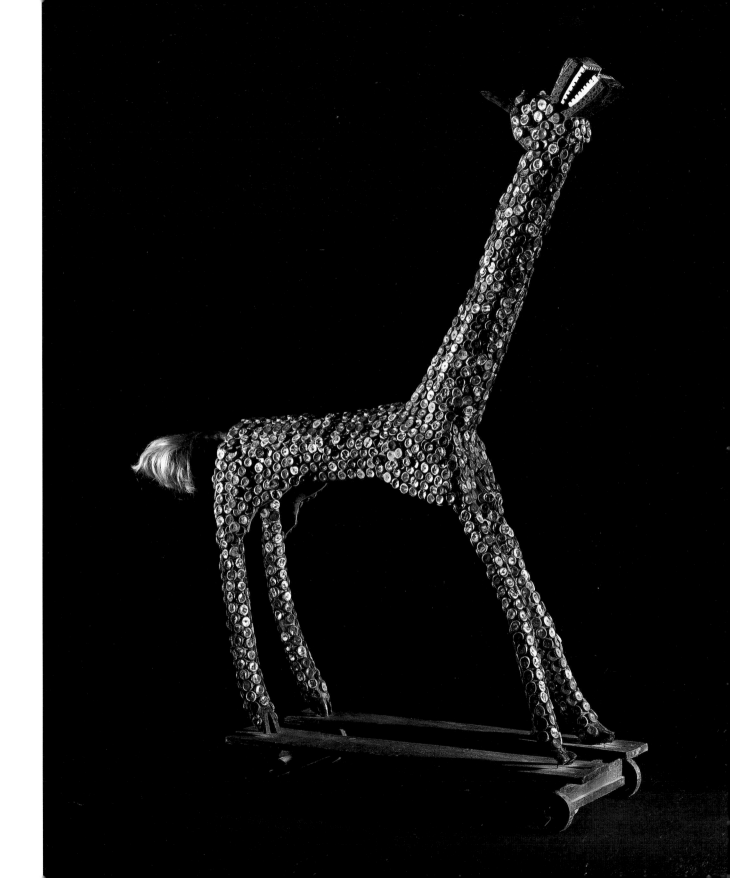

**HORACIO VALDEZ**

1929–1992

## *Carreta de Muerte* (Death Cart)

1978, painted
cottonwood, hair,
and leather
141 x 131.8 x 83.2 cm
Smithsonian
American Art
Museum, Gift of
Chuck and Jan
Rosenak and
museum purchase
through the Luisita L.
and Franz H.
Denghausen
Endowment

The grim reaper rides toward us in a medieval cart, poised to claim new victims with his bow and arrow. A hollow-eyed skeleton, he has long, gray hair and his widely spaced buck teeth are fixed in a humorless grin. Besides his bow and arrows, he carries an ax in a leather holster fastened to one side of the cart. He is a traditional sculptural form within the religiously grounded, two-hundred-year-old *santero* wood-carving tradition of northern New Mexico. Valdez's multiple versions are among the more powerful examples of these mobile sculptures, which are sometimes used in religious processions.

A former carpenter, Valdez carved a variety of other religious forms in loose accordance with the *santero* tradition. His frequent repetition of the *carreta de muerte* was no doubt partly market-driven, but it also reflects personal experience. In 1974, when he was forty-five years old, he was involved in a near-fatal accident on a dam-construction site, which crushed his right hand and left him permanently disabled. Around the same time, he was initiated into Los Hermanos Pentitentes, a religious fraternity of Hispanic, Catholic men. The carved wooden saints in the small chapel used by the penitentes inspired him to begin making religious sculptures.

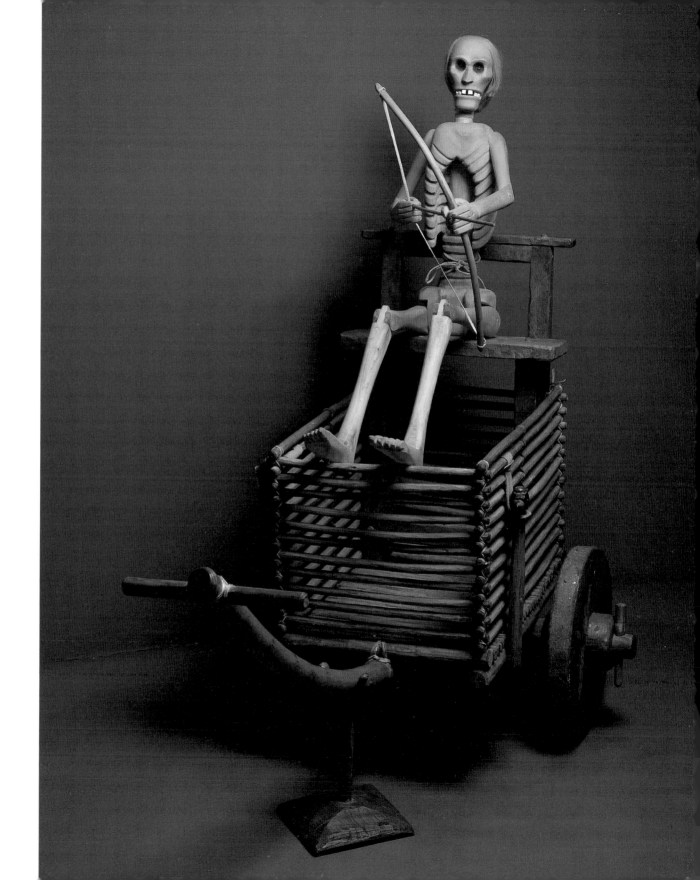

# GEORGE W. WHITE JR.

1903–1970

## Emancipation House

1964, oil on wood,
cloth, paper, and
found objects
49.5 x 59.2 x 47 cm
Smithsonian
American Art
Museum

George White included commentary and recollections in the narrative relief panels and three-dimensional tableaux that he made after 1957. Although he emphasized his experience as a southern black man in constructions such as Emancipation House, his intent was often ambiguous, as was his use of stereotypical imagery in humorous or exaggerated form. White maintained that this sculpture dealt with the "emancipation" of sexual awareness. Originally, the kerchiefed woman stood outside the outhouse, so frightened by a snake that her bodice had burst, fully exposing her bosom to a boy positioned outside the gate. Around 1975 the artist's widow removed the boy and reclothed and shifted the woman. Details such as the illustration of Abraham Lincoln's inauguration and the men at work in a humble rural setting may also suggest White's perception of the lives of African Americans long after the Emancipation Proclamation. Whatever the message, White delivered it in an entertaining fashion. He even installed electrical wiring to activate the figures on the roof and illuminate the cabin's interior. The wiring, however, is no longer operational.

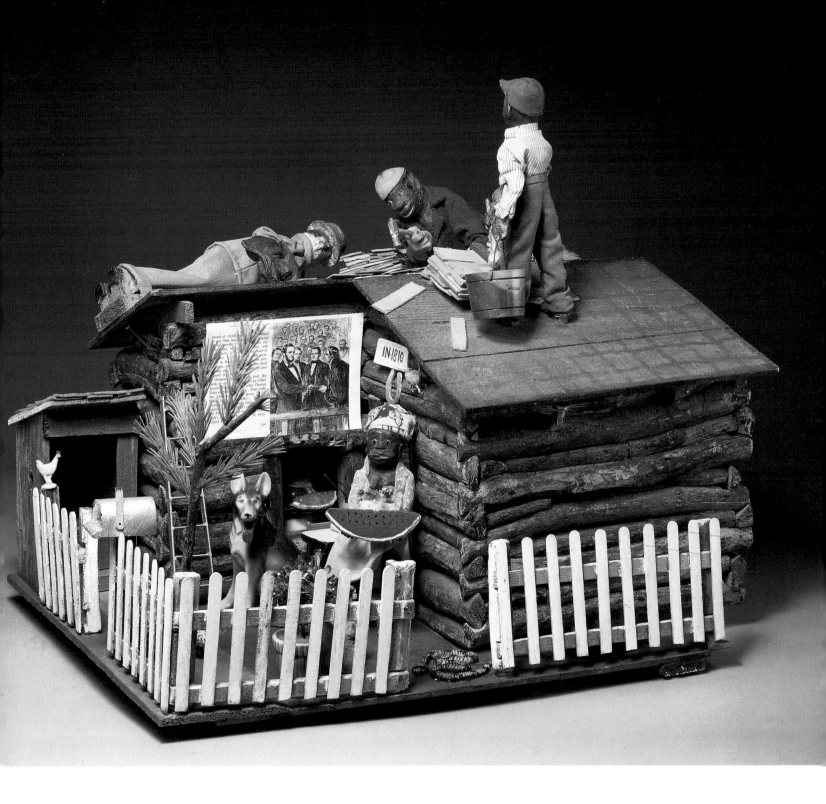

**CHARLIE WILLETO**

1906–1964

# Male and Female Navajo Figures

about 1962–64
painted wood
168.3 x 42 x 26.1 cm
169 x 41.3 x 36.2 cm
Smithsonian
American Art
Museum, Gift of
Herbert Waide
Hemphill Jr. and
museum purchase
made possible by
Ralph Cross Johnson

Most of the four hundred carvings Willeto created are small, reminiscent of the carved figures used in a Navajo curing rite. Ranging from four to eight inches in height, the traditional figures were left at sacred places, along with prayer sticks representing male and female forms. Willeto's pair of large sculptures—the biggest he produced—differ from the stylized carvings only in scale, and their painted markings may be decorative references to the jeweled inlay and painted bands characteristic of the healing figures. This stately pair, their hair bound Navajo style, stood outside the Mauzy Trading Post, where Willeto often traded his sculptures for groceries and other goods. Originally brightly painted, the figures are decorated with color that has been dulled by exposure to the elements.

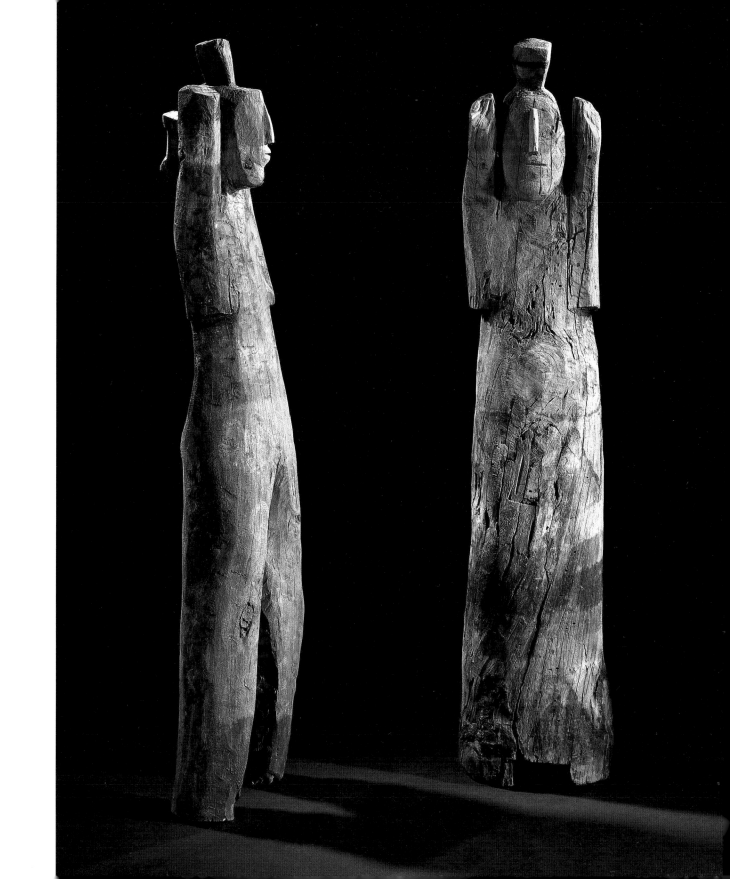

**PURVIS YOUNG**

born 1943

## *Untitled*

about 1988
acrylic on plywood
102.9 x 123.2 cm
Smithsonian
American Art
Museum

This herd of graceful, wild horses, their legs elegantly elongated and muscular necks curved, is far from the urban landscape Young inhabits. Turbulence swirls around these creatures that stand their ground as symbols of beauty, freedom, and power, while human figures lie prone in defeat, making gestures of protest, supplication, or despair. Young paints on scrap lumber and plywood that he scavenges from the streets and vacant lots of Overton, the historically black neighborhood where he lives in Miami, Florida, and whose long deterioration he has witnessed. He sometimes depicts his surroundings literally, but in this work he paints what he sees with his "inner eyes"—and transcends the misery that surrounds him.

Young has pursued a keen interest in art by studying books in his local libraries. When he began painting, he was inspired by the popular mural movement of the 1960s. He hung his paintings of tenement life and animals on the exterior walls of abandoned buildings in his neighborhood.

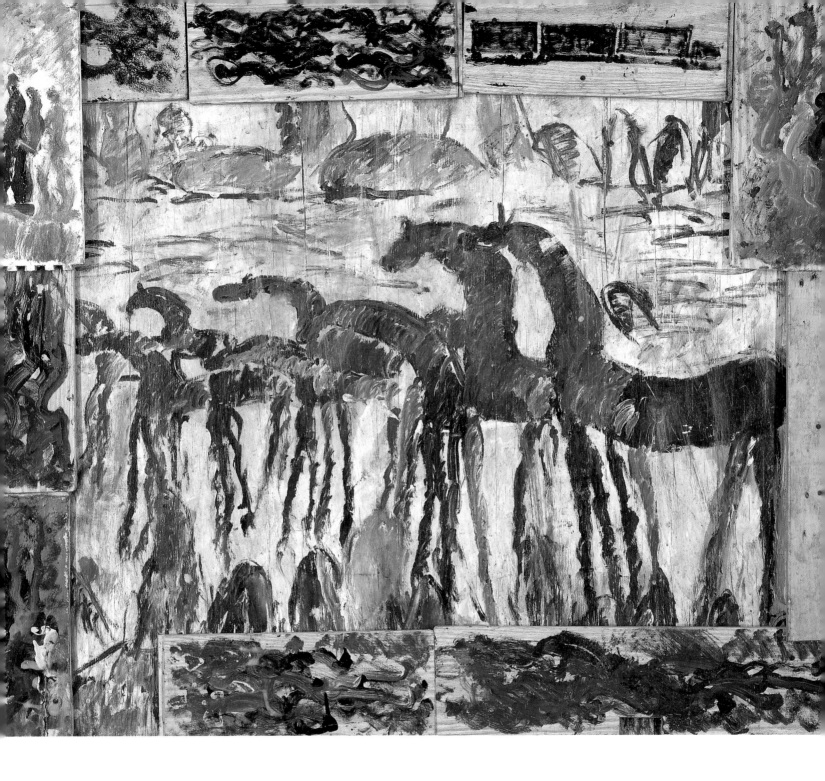

## MALCAH ZELDIS

born 1931

## *Miss Liberty Celebration*

1987, oil on
corrugated
cardboard
138.4 x 92.7 cm
Smithsonian
American Art
Museum, Gift of
Herbert Waide
Hemphill Jr.

Recalling the centennial celebration for the freshly restored *Statue of Liberty* on July 4, 1986, this elaborate image of a festive New York Harbor and the city skyline also celebrates Zeldis's recovery from cancer that year. A stylized, golden-orange *Liberty* holds her torch aloft. The flame is amplified by comic-book-style fireworks exploding in the sky over the brilliantly colored harbor. Ellis Island is just beyond her left hand and the book it clutches. She is surrounded by fluttering flags and a flotilla of boats, as well as more than one hundred individual figures, including such cultural icons as Abraham Lincoln, Albert Einstein, Ludwig von Beethoven, Charlie Chaplin, Elvis Presley, and Marilyn Monroe. The crowd includes friends of the artist and members of her family, as well as Zeldis herself. As the eye moves to the anonymous high-rise buildings that frame the scene, the spectators blend into anonymity as well.

Liberty and liberation are resonant themes for Zeldis, a Detroit native who spent her early adult years in Israel, moved to New York in 1958, began working as a teacher's aide, and took up painting around 1960. Zeldis has acknowledged influences ranging from the Flemish masters to Haitian folk art.

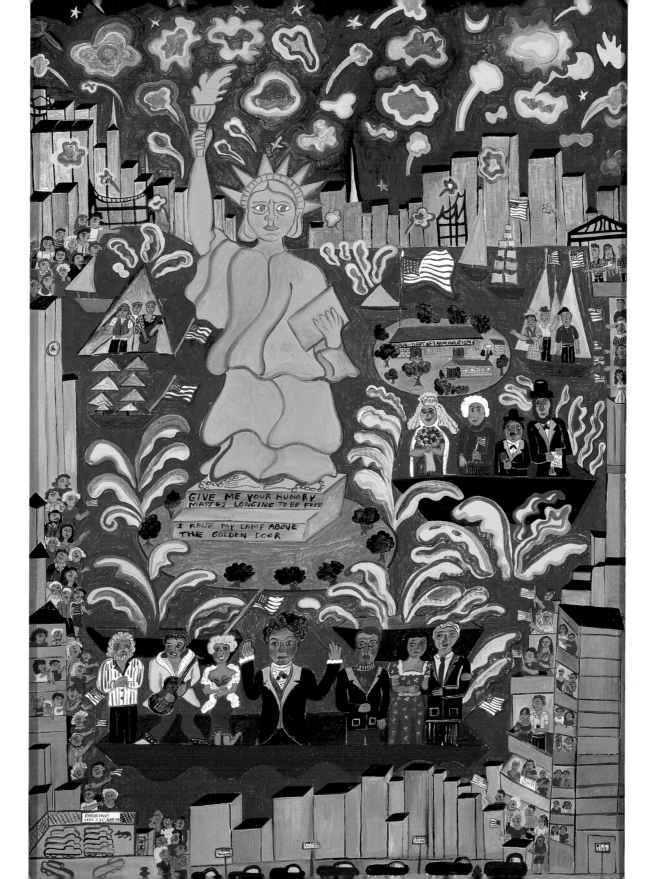

GIVE ME YOUR HUNGRY
MASSES LONGING TO BE FREE

I RAISE MY LAMP ABOVE
THE GOLDEN DOOR

## Index of Titles

The Smithsonian American Art Museum is dedicated to telling the story of America through the visual arts. The museum, whose publications program includes the scholarly journal *American Art*, also has extensive research resources: the databases of the Inventories of American Painting and Sculpture, several image archives, and fellowships for scholars. The Renwick Gallery, the nation's premier museum of modern American decorative arts and craft, is part of the Smithsonian American Art Museum. For more information or catalogue of publications, write: Office of Print and Electronic Publications, Smithsonian American Art Museum, Washington, D.C. 20560-0230.

The museum also maintains a World Wide Web site at **AmericanArt.si.edu.**